CAPE MAY
THROUGH TIME

DR. JOSEPH SALVATORE
AND JOAN BERKEY

AMERICA
THROUGH TIME®
ADDING COLOR TO AMERICAN HISTORY

America Through Time is an imprint of Fonthill Media LLC
www.through-time.com
office@through-time.com

Published by Arcadia Publishing by arrangement with Fonthill Media LLC
For all general information, please contact Arcadia Publishing:
Telephone: 843-853-2070
Fax: 843-853-0044
E-mail: sales@arcadiapublishing.com
For customer service and orders:
Toll-Free 1-888-313-2665

www.arcadiapublishing.com

First published 2018

ISBN 978-1-63500-065-8

Typeset in Mrs Eaves XL Serif Narrow
Printed and bound in Great Britain by CPI Group (UK) Ltd, Croydon CR0 4YY

INTRODUCTION

Cape May, located at the tip of a peninsula in southeastern New Jersey bordered by the Atlantic Ocean and the Delaware Bay, is named for Cornelius Jacobsen Mey (later spelled May), a Dutch captain who sailed around her shores between 1616 and 1624. Beginning in the 1680s, English-speaking farmers and whalers from New England were the first to permanently settle here, calling the area Cape Island until it was renamed in 1869. For several centuries previous to their arrival, the land was home to the Lenni Lenape Native Americans.

By the Revolutionary War, the island's sugar sand beaches and salt air had become so popular for recreation that local resident Robert Parsons advertised the sale of a house and 254 acres "open to the Sea ... and within One Mile and a Half of the Sea Shore; where a Number resort for Health, and bathing in the Water; and this Place would be very convenient for taking in such people ... " Thus began the oldest seashore resort in the country.

In July 1801, Cape Island resident Ellis Hughes advertised rooms in his public house for people who wanted to bathe in the sea, offering them meals of locally-caught oysters and fish accompanied by fine liquors. Hughes proclaimed the area "the most delightful spot the citizens can retire to in the hot season."

Travelers arrived by private carriage, stage, or by a boat from Philadelphia's busy docks. Regular steamboat service on side-wheeler paddle boats between Philadelphia and the resort began in 1819. By 1834, Cape May boasted six boarding houses; the largest—Congress Hall—was one block long and fifty feet wide. These early, wooden hotels were plain in design both inside and out, topped with a gable roof and having nothing more than a tall veranda supported by slender wooden posts. Nevertheless, Cape May's popularity as a resort continued to grow as increased competition between steam boat operators dropped the cost of passage significantly.

By the mid-nineteenth century, nearly two dozen hotels located mostly on three blocks between Perry and Ocean streets, along with several private residences, offered rooms capable of housing nearly 3,000 summer visitors at a time.

When city residents sided with the Union in the Civil War, they lost a significant amount of business from the thousands of wealthy southern planters and merchants who had vacationed there every summer for decades. However, the long-awaited completion of a rail line from Camden to Cape May in 1863 brought renewed optimism and new growth to the resort.

Disaster struck in August 1869 when fire consumed two blocks in the city's oldest section, destroying three hotels and several commercial buildings on Jackson Street, along with numerous cottages and boarding houses; they were all built of wood. Except for the Columbia Hotel, spared when the wind shifted, everything in the area bordered by the beach, Washington Street, Ocean Street, and Jackson Street was leveled to ashes. Only one of the three hotels was rebuilt and much of the land was parceled into building lots.

In November 1878, the city suffered another devastating fire. Thirty-five acres between Gurney and Congress Streets burned to the ground, destroying seven hotels along with more than thirty cottages and rooming houses. These were quickly replaced with new buildings designed in a wide range of Victorian-era architectural styles, many embellished with "gingerbread trim" and wide bracketed porches.

In the early 1900s, two successive developers sought to transform a barren 3,500-acre section of Cape May located east of Madison Street. Although the boardwalk was extended, new streets were created, and a new hotel opened in 1908, relatively few houses were built and both developers went bankrupt. The eastern third of the property was then acquired by the United States Navy during World War I and is today home to the U.S. Coast Guard's only recruit training center.

As the automobile changed the way tourists vacationed, Cape May entered a slow decline. Even the completion in 1954 of the 173-mile long Garden State Parkway failed to bring the crowds back to the city that had once been called the "queen of seaside resorts."

Momentum grew in the 1960s to use the city's rich history as a way to bring vacationers back and extend the season by offering tourists an alternative to the beach. In 1970, most of the city was placed on the National Register of Historic Places. In 1976, the historic district was declared a National Historic Landmark, the highest national designation possible, recognizing it as the best, single, unified area of Victorian-era architecture east of the Mississippi. Around this time, a handful of owners converted their historic cottages into bed-and-breakfast inns; others followed suit and today the city boasts more than fifty.

In addition to providing summer visitors a world-class beach, Cape May today offers exciting new programs, festivals, and specialty tours that extend the season from April through December. These have been enhanced with other nearby heritage tourism sites, including the Cape May lighthouse, a WWII lookout tower, Historic Cold Spring Village open air living history museum, and Naval Air Station Wildwood Aviation Museum.

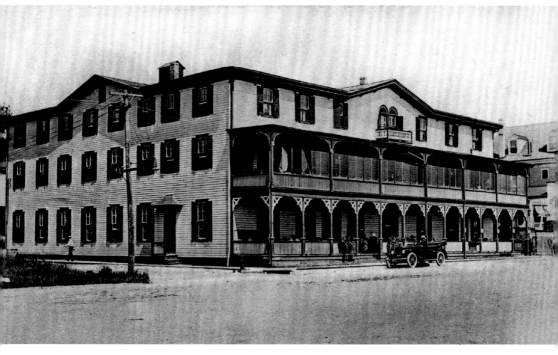

HOTEL ALCOTT: First known as the Arlington House, the large Hotel Alcott (pictured) and the Chalfonte are the only two hotels that survive from the years before the Great Fire of 1878. Built that same year for John Kromer of Baltimore, the Hotel Alcott catered to working class women and their children. Extensively restored and still serving as a hotel, the building stands on Grant Street opposite the original location of the demolished Pennsylvania Railroad summer station.

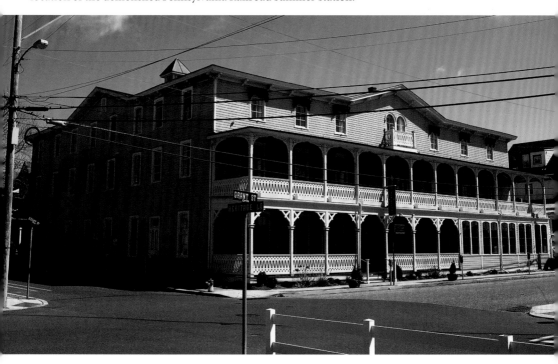

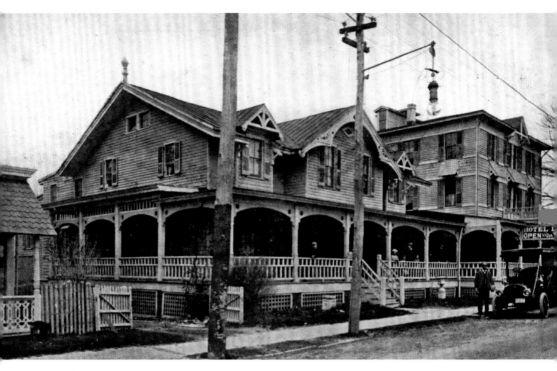

HOTEL DEVON: Built before 1890 on South Lafayette Street, the hotel appears to be two separate cottages joined to make one hotel. Shown here in the early 1900s, it had a total of fifty guest rooms and offered meals. Rates advertised in 1913 were "$1.50 per day and up." The present building on the lot is reportedly the same hotel, greatly rehabilitated and converted into condominiums.

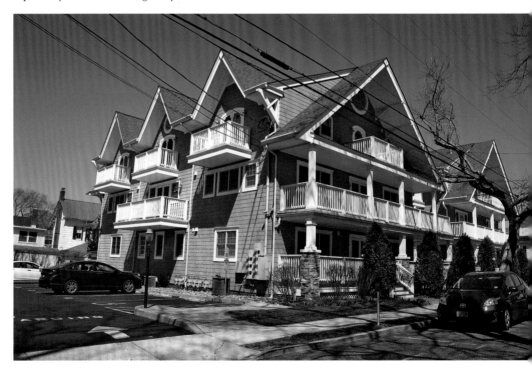

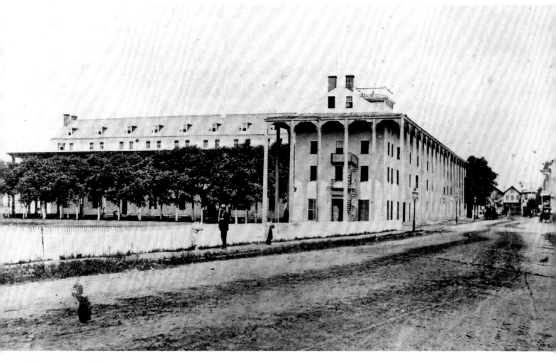

COLUMBIA HOUSE: Seen here about 1875, the Columbia House was built in 1846 for Captain George Hildreth and straddled the oceanfront block between the newly opened Ocean and Decatur Streets. By 1850, it had expanded to be the largest hotel on Cape Island. Although the Columbia House was spared in the 1869 fire, it was totally consumed in the Great Fire of 1878 and was not rebuilt.

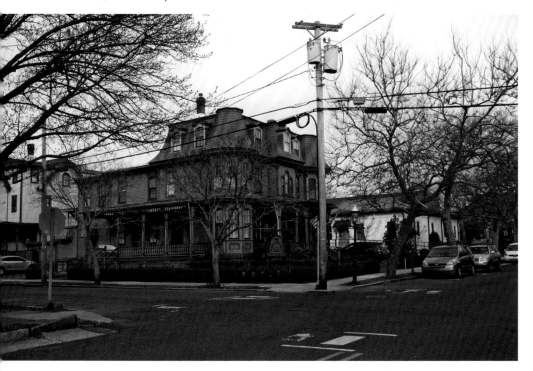

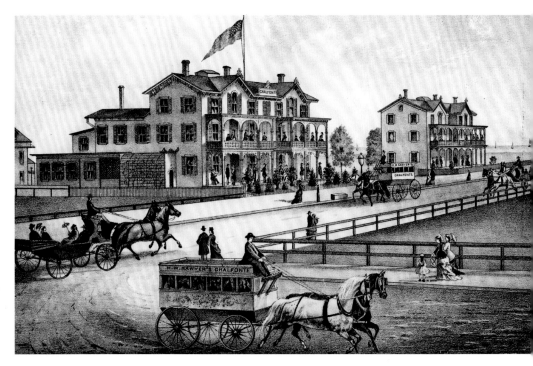

CHALFONTE HOTEL: Civil War hero Colonel Henry Sawyer built this handsome three-story rooming house in 1876 at the corner of Howard and Sewell Streets where it still stands and continues to welcome guests. Later additions expanded the building to its present size. Sawyer was the first to turn in the alarm for the Great Fire of 1878, and his building was luckily spared. The drawing, which depicts the hotel's original appearance, dates to 1878.

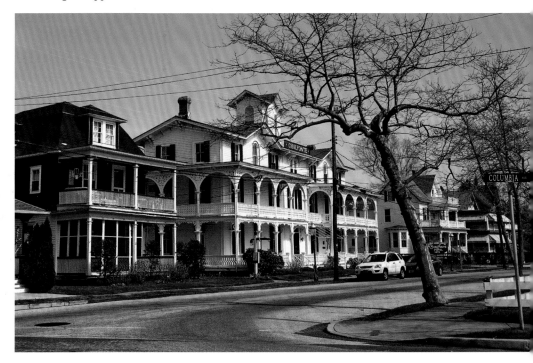

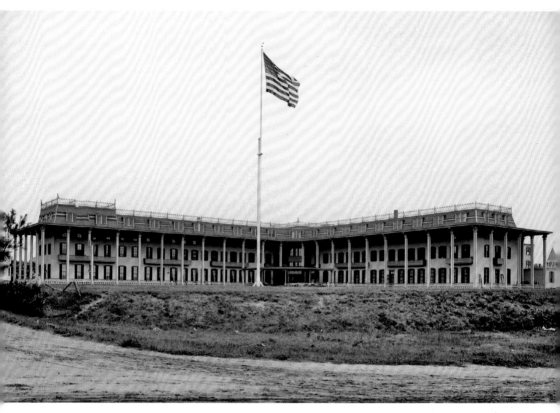

CONGRESS HALL: Built in 1879, this hotel is the third of that name to stand on the oceanfront lot. The present building, erected of brick, replaced the 1850s wooden hotel that burned in the Great Fire of 1878. Smaller and closer to the ocean, it opened in time for the 1879 season. Congress Hall was extensively restored in the early 2000s and caters to visitors year-round.

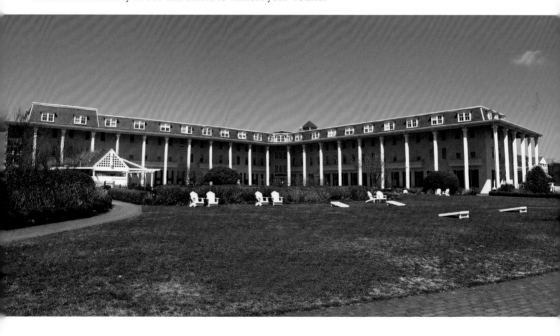

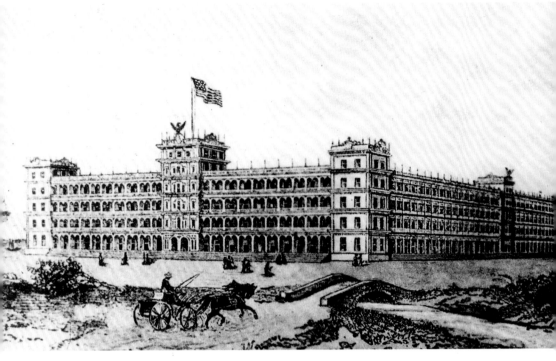

MT. VERNON HOTEL: Touted as the largest hotel in the world when it was built in 1853, the massive Mt. Vernon stood on 10 beachfront acres near Broadway. Each of its 3,500 rooms had a bathroom with hot and cold water, a novelty at the time. The structure's 400-feet-long-by-300-feet-wide dining room accommodated 3,000 in one sitting. The hotel burned to the ground in 1856 and was never rebuilt.

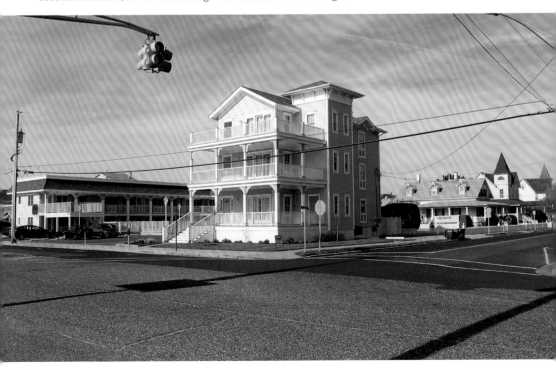

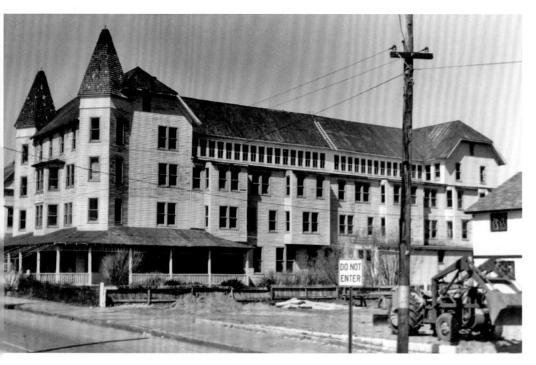

BALTIMORE INN: Completed in 1893 near the foot of Jackson Street and named for the southern city from where many of the resort's visitors came, this twin-towered hotel featured eighty-eight guest rooms. It was designed and built by local architect Enos Williams who cleverly put the hotel's enormous ballroom on the top floor where views of the ocean were unobstructed by neighboring buildings. Vacant when photographed in 1964 (above), it was demolished in 1971.

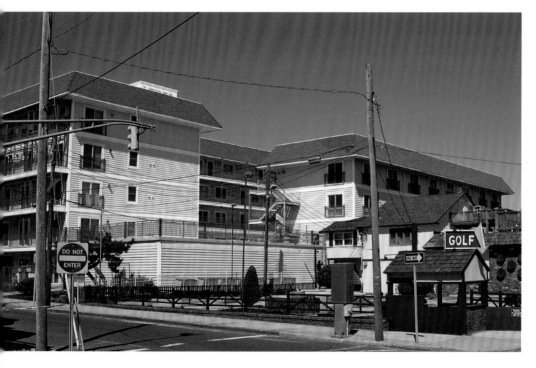

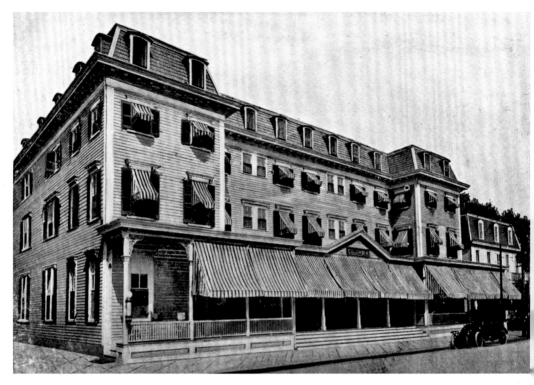

COLUMBIA HOTEL: The parking lot for the Victorian Towers apartments located near the corner of Washington and Ocean Streets occupies the Columbia Hotel's site. Built in 1874, it was originally named the Arctic. When the Chalfonte Hotel proprietor Colonel Henry Sawyer leased it in 1890, he changed the name to the Columbia. It escaped the Great Fire of 1878, but succumbed to the wrecking ball in the 1960s.

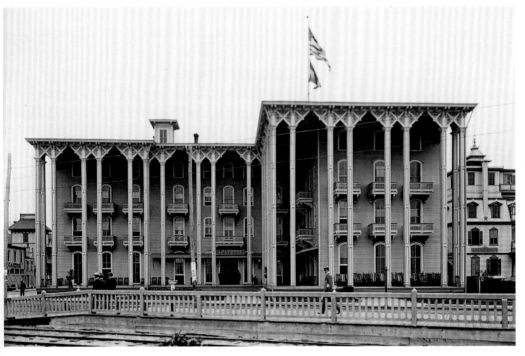

LAFAYETTE HOTEL: Noted Philadelphia architect Stephen Decatur Button designed the Lafayette Hotel, erected in 1884, and three other waterfront hotels after the devastating Great Fire of 1878. Sited at the foot of Decatur Street, it offered 125 rooms placed in an L-shaped format to maximize the number of rooms with an ocean view. The Lafayette was demolished in 1970 and replaced with the present Marquis de Lafayette Hotel.

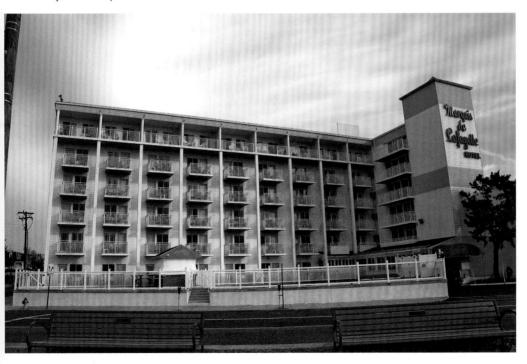

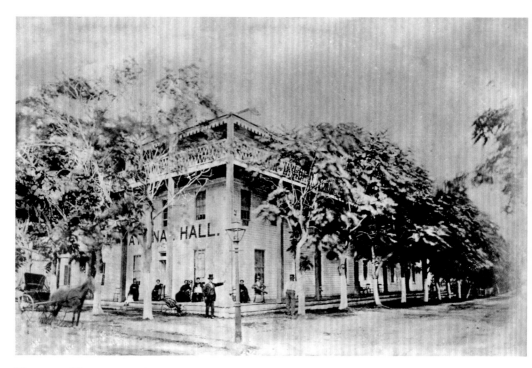

NATIONAL HALL: Aaron Garretson built this three-story hotel, which no longer stands, about 1850 at the corner of Corgie and Franklin Streets. At the time, National Hall was several blocks north of the commercial district and it had magnificent, unobstructed views of the ocean. To draw more guests, Garretson charged "children and servants half price;" he also served no liquor. National Hall's simple, box-like design embellished with wraparound porches was typical of Cape May's early hotels.

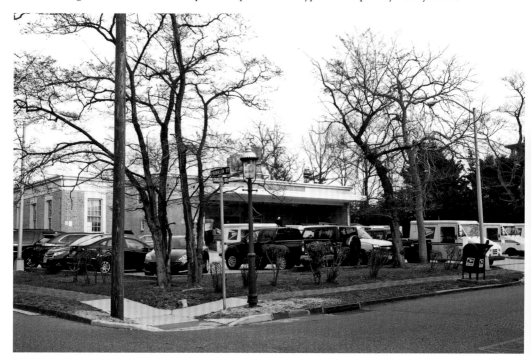

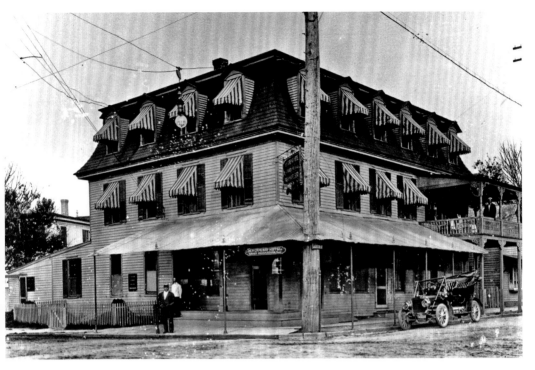

NEW CAPE MAY HOTEL: Harry Richardson's New Cape May Hotel at the corner of Broad and Jackson Streets is the only one still standing of at least five hotels in the city owned by African Americans and operated for the African American tourist trade. Today the building holds shops. A Philadelphia native, Richardson also owned an opera house in town that catered to an African American clientele.

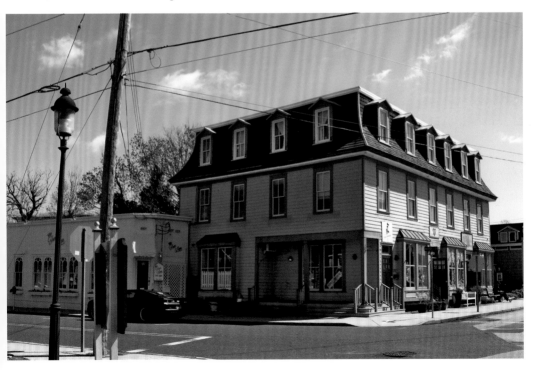

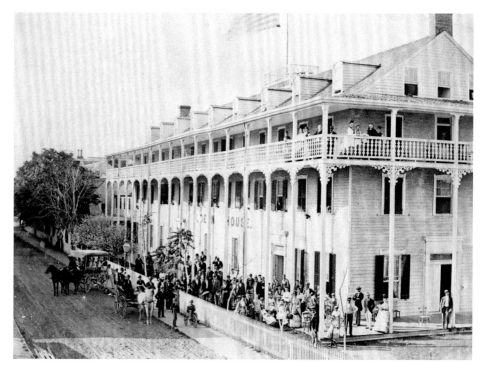

OCEAN HOUSE: Built in 1856 on Perry Street, opposite Congress Hall, the Ocean House held 400 guests. At the beginning of the 1877 season, its owners spent more than $30,000 refurbishing the entire hotel. Fully insured, it burned to the ground one year later in the Great Fire of 1878. Because the fire started here, some newspaper accounts claimed that its proprietor, S. R. Ludlam, was the arsonist, but he was never convicted.

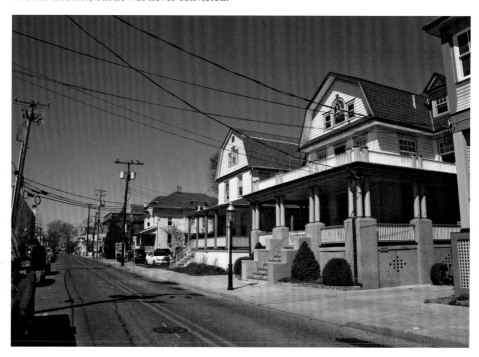

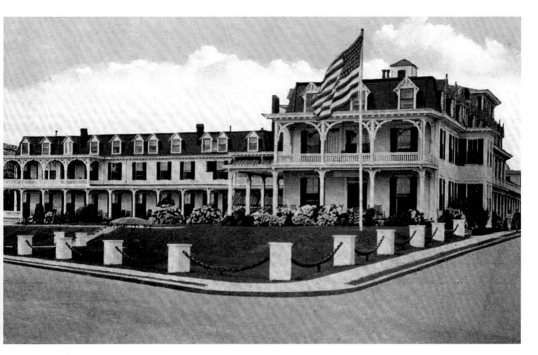

WINDSOR HOTEL: In 1879, Thomas Whitney took his existing oceanfront cottage, hired Philadelphia architect Stephen Decatur Button to expand the building, and when complete named it the Windsor Hotel. George Hildreth's *ca.* 1852 cottage next door, West End House, was later annexed to the hotel. The Windsor Hotel was destroyed by a suspicious fire in May 1979 and the site now hosts a modern hotel.

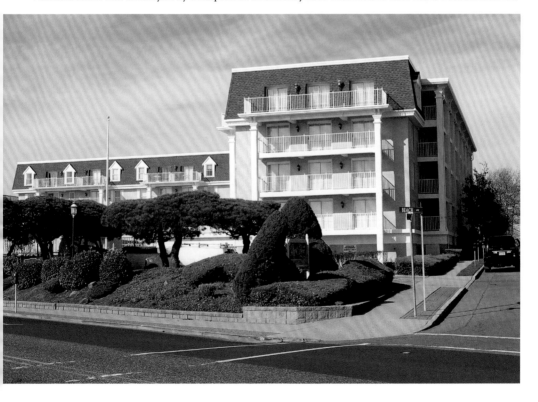

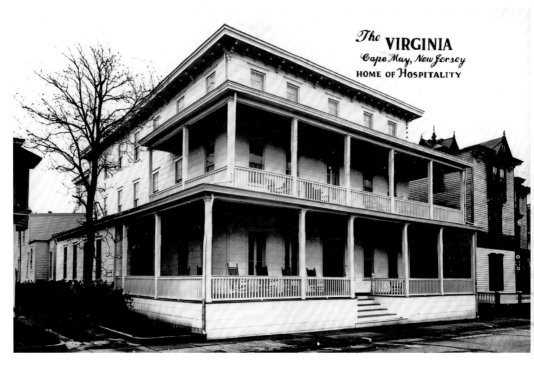

The **VIRGINIA**
Cape May, New Jersey
HOME OF Hospitality

THE VIRGINIA: Built in 1879 as the Ebbitt House, this three-story hotel on Jackson Street replaced an earlier building on the lot that burned in the Great Fire of 1878. By the early 1900s, it was renamed the Virginia Hotel and was probably remodeled about that time with the Colonial Revival style porches seen above. The Virginia was restored to its original appearance in the 1980s and has twenty-four guest rooms.

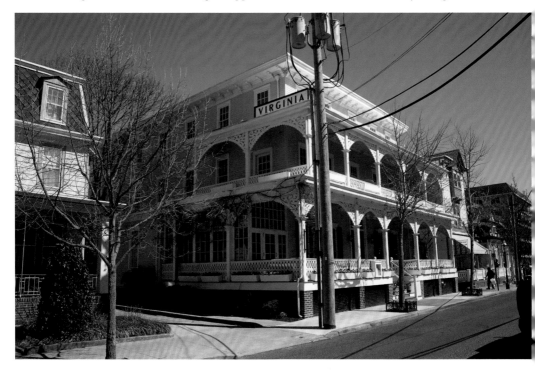

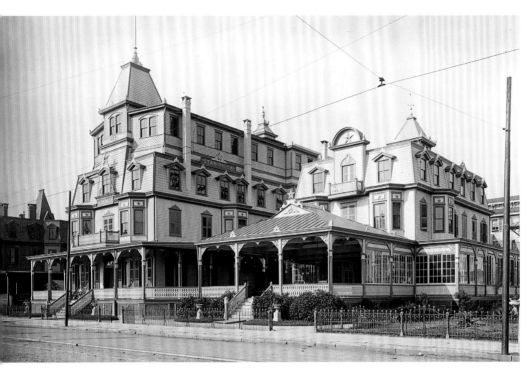

STAR VILLA: Looking more like two large cottages than a hotel, Star Villa opened for business on Ocean Street the summer of 1885, offering visitors their choice of forty rooms. The fourth story was added in 1893. Both sections, and their star embellishments, were moved to Beach Avenue near Trenton Avenue in 1967, but only the taller of the two survives and has been converted into condominiums.

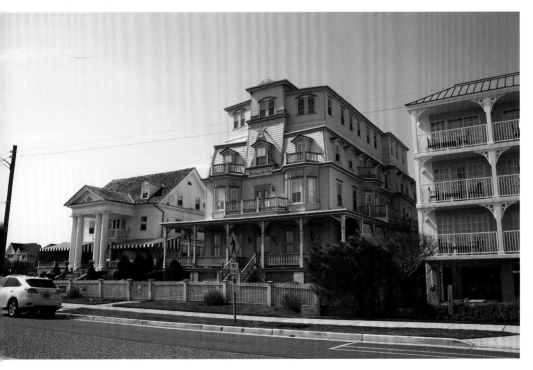

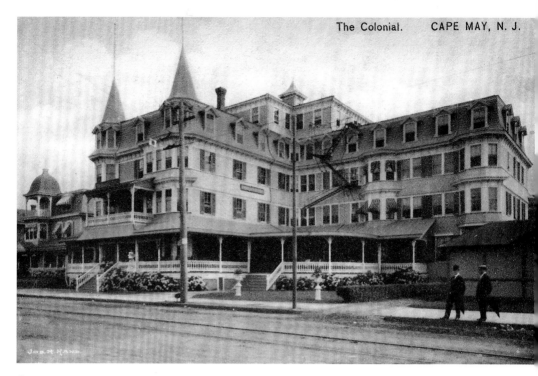

COLONIAL HOTEL: Built in 1894 by its owners, William and C. S. Church, who were also contractors, the Colonial Hotel still stands near the foot of Ocean Street. The south wing, which overlooks the ocean, was built in 1905. For many years, William Church was the hotel's proprietor. The building's twin towers and mansard roof recall other city hotels built in the same period.

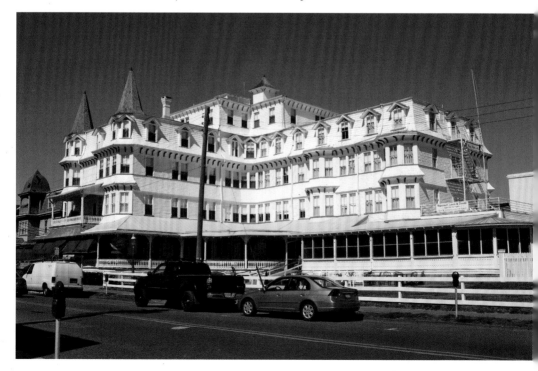

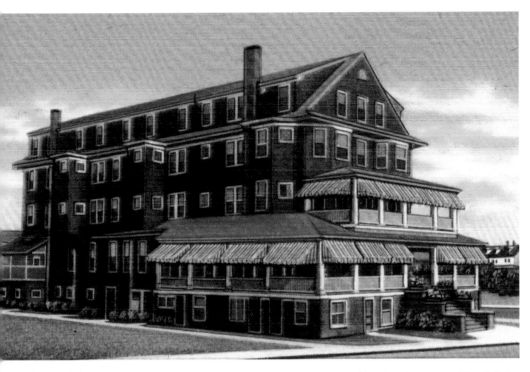

HOTEL MACOMBER: Mrs. Sara Davis built this huge, shingle-covered hotel at the corner of Beach Drive and Howard Street about 1920. It was built on less than one-fifth of the lot that had been previously occupied by the mammoth Stockton Hotel which was demolished in 1911. The Macomber's shingle style reflects a move away from the Victorian-era styles for which the city is famous.

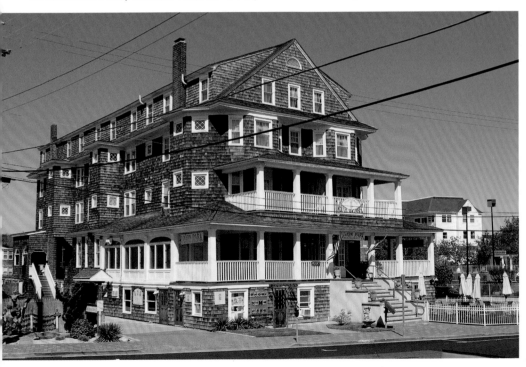

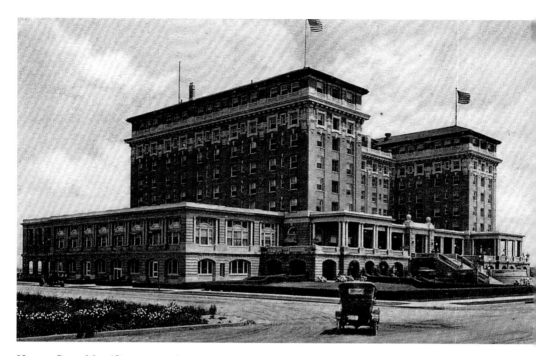

HOTEL CAPE MAY/CHRISTIAN ADMIRAL: Construction of the Hotel Cape May near the east end of Beach Avenue began in 1905, but the building was not completed until 1908. Erected at a cost of $1 million—nearly twice the estimate—it featured 350 rooms, grand lobbies, elegant staircases, and several dining rooms. The hotel anchored a residential development scheme in East Cape May that failed one year later. It was used as a military hospital during World War I and was ultimately demolished in 1996.

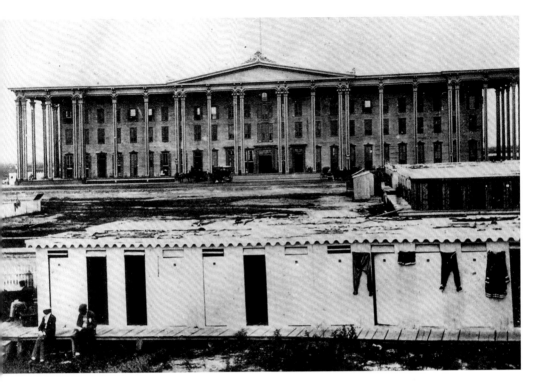

STOCKTON HOTEL: Designed by noted Philadelphia architect Stephen Decatur Button, this mammoth hotel occupied a choice waterfront block between Gurney and Howard Streets. It was built in 1869 by the West Jersey Railroad at a cost of $300,000 and featured 475 guest rooms. The dining room seated 800 people at one time. Financial problems plagued the building's original and subsequent owners, and the hotel was torn down in 1910.

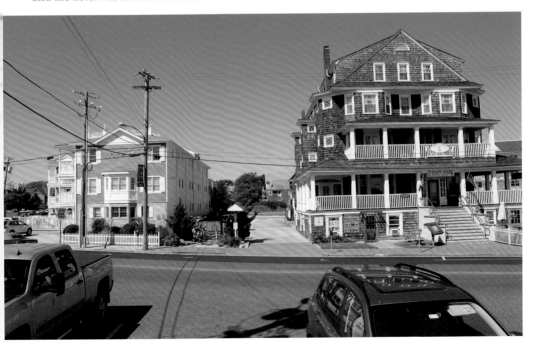

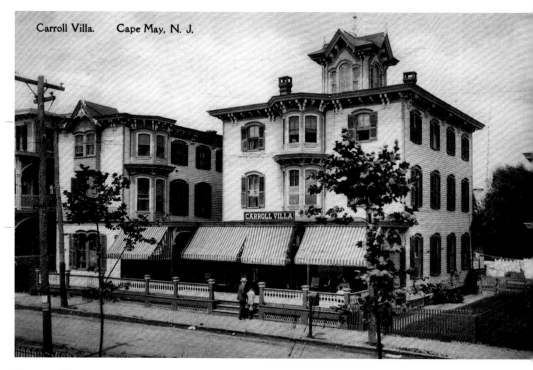

Carroll Villa. Cape May, N. J.

CARROLL VILLA: Built in 1882, this cottage-like hotel on Jackson Street was erected for George Hildreth, former owner of two city hotels and whose cottage on South Lafayette Street burned down in the 1878 fire. In the 1880s, nearly half of the city's visitors hailed from Baltimore and Hildreth, hoping to attract them, named his hotel after Baltimorean Charles Carroll, a signer of the Declaration of Independence.

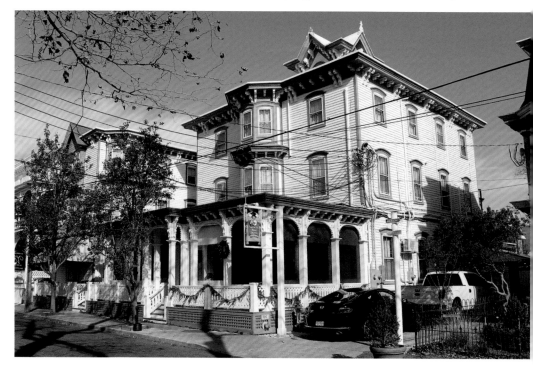

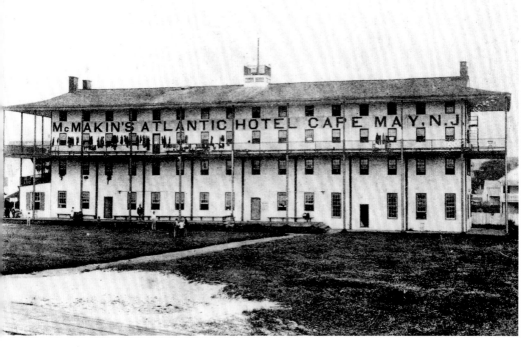

ATLANTIC HOTEL: One of the earliest to offer summer accommodations and the first to have a painted exterior, the Atlantic Hotel was built in 1842 by steamboat captains Joseph and Benjamin McMakin from Philadelphia. Fronting the ocean at Jackson Street, the box-like structure held 300 guests and featured a large dining hall that occupied most of the first floor. It burned to the ground in 1869; modern stores and late-nineteenth-century houses occupy its site.

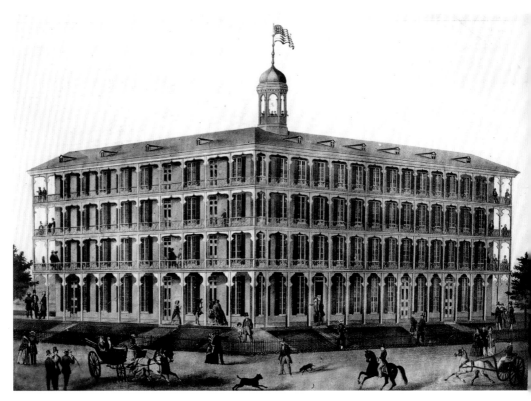

UNITED STATES HOTEL: Turn-of-the-last-century buildings stand today where A. W. Tompkins built this elegant four-story hotel at Washington and Decatur Streets in the heart of Cape May's commercial district. It opened in 1850 and held 400 guests. Within the first two months of operation, it had suffered four minor fires that were deliberately set but were quickly extinguished; the arsonist was never apprehended. Unfortunately, the hotel succumbed to a devastating fire in 1869 and was not rebuilt.

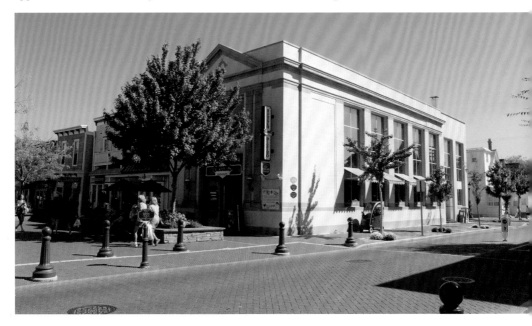

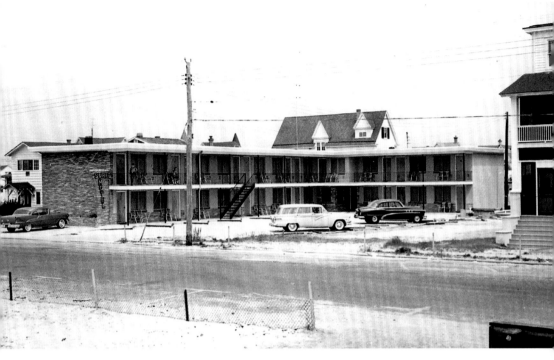

SURF MOTEL: Motor hotels, or "motels" as they came to be called, catered to the tourist who arrived in a car rather than by boat or train. The Surf Motel, now known as the Mt. Vernon Motel, was built in the 1950s on Beach Avenue. It offered convenient parking in a large lot and direct outdoor access to its rooms, two conveniences not found in the city's older hotels and boarding houses.

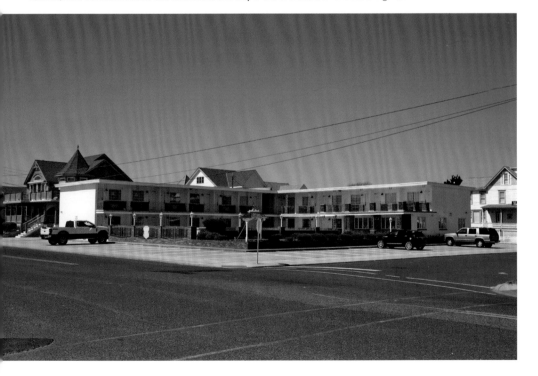

TREMONT HOUSE: Its former site at the corner of Washington and Franklin Streets is now home to a modern local bank. Built sometime before 1850, the Tremont House was one of the city's earliest boarding houses and offered 125 guest rooms. In the 1850s, rooms cost $1.50 per day or $9 for the week and included three meals a day. It was torn down at the turn of the last century.

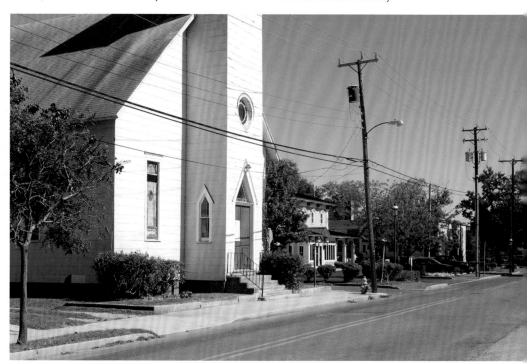

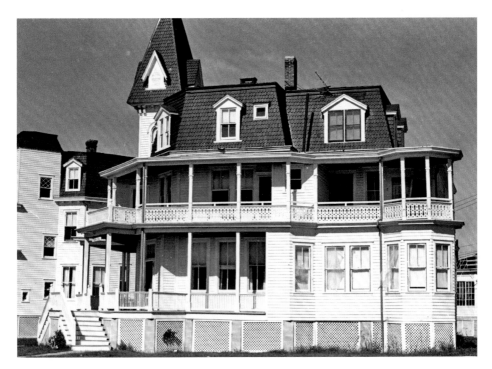

WEIGHTMAN COTTAGE: Built about 1860 for Philadelphian William Weightman, the cottage was moved in two pieces from its original location on Washington Street to the corner of Beach and Ocean Avenue in 1881. At that time, the tower was added and other improvements made. In 1963, both pieces were moved to their present site on Trenton Avenue. They have since been restored and converted into a bed-and-breakfast inn. The photo above was taken in the 1960s at the current site.

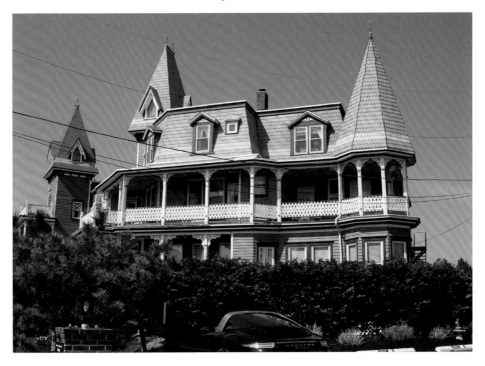

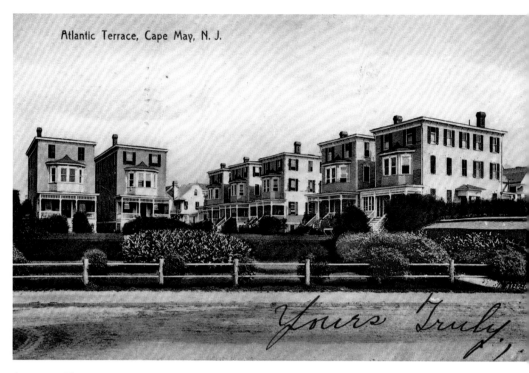

Atlantic Terrace, Cape May, N. J.

ATLANTIC TERRACE: This group of seven single-family cottages was built in 1892 on the site of the New Columbia Hotel, which burned to the ground in 1889. They were designed by Philadelphia architect Stephen D. Button, whose plan of grouping them around a court was a novel idea for Cape May at the time. Standing between Jackson and Perry Streets, each cottage had a spectacular view of the ocean. All survive today.

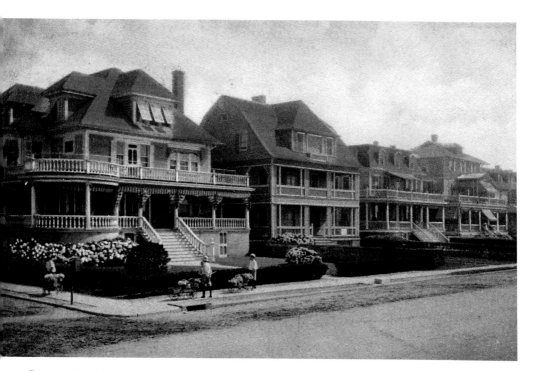

BEACH AVENUE COTTAGES: Vacant land on Beach Avenue east of Jefferson Street was developed beginning in the late 1800s. Seen above about 1920 at the corner of Jefferson Street and Beach Avenue is a row of summer cottages built in the popular styles of the day, including Colonial Revival, Dutch Colonial Revival, and American Foursquare. Facing the Atlantic Ocean, all have retained their expansive front porches that capitalize on the waterfront views.

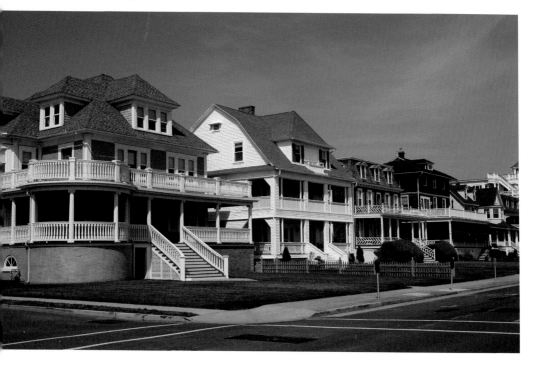

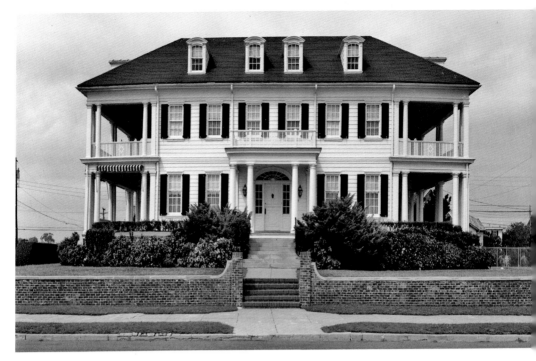

GEORGE BOYD HOUSE: Little changed since it was built in 1911, this Georgian Revival style home was erected for George Boyd, general passenger agent for the Pennsylvania Railroad and promoter of a real estate development on vacant land in East Cape May. Despite construction of the now-demolished Hotel Cape May, which was meant to spur the sales of cottage lots around it, the development foundered and went bankrupt in 1915.

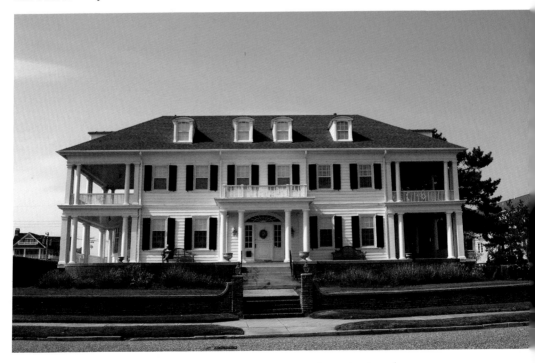

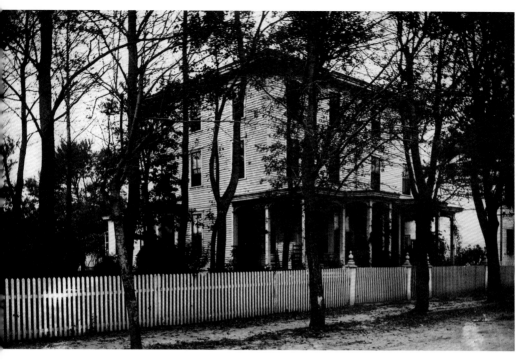

LEACH HOUSE: This Italianate-style house was built on Lafayette Street about 1870 for Joseph Leach, publisher and editor of the city's newspaper, the *Cape May Ocean Wave*, for a number of years. In that position, he greatly influenced the building of the railroad to Cape May City in 1863, thereby greatly shortening travel time to the resort. He held many elected positions and served as county freeholder for six years. The house has been converted into condominiums.

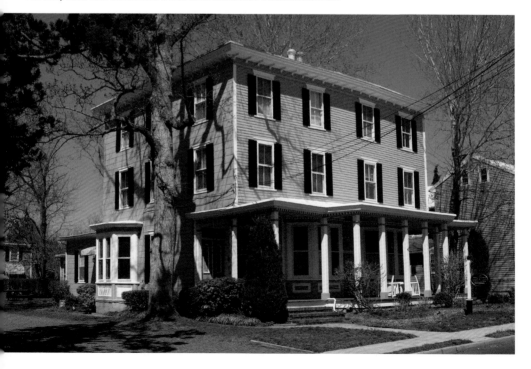

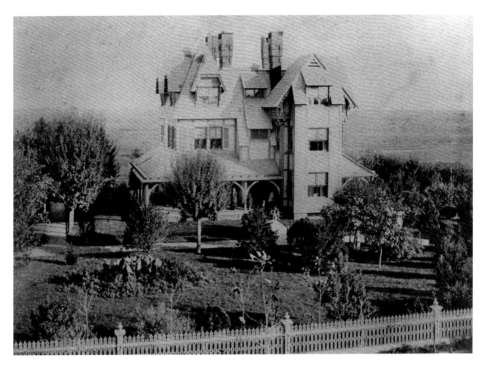

PHYSICK HOUSE: Philadelphians Mrs. Frances Physick Ralston and her son, Dr. Emlen Physick Jr., built this house in 1878 on Washington Street. Although trained as a physician, Physick never practiced, becoming instead a successful real estate entrepreneur. Physick family members lived here until 1935. After decades of neglect, the mansion was restored in the 1970s by the Mid-Atlantic Center for the Arts and Humanities, which operates the site as a historic house museum.

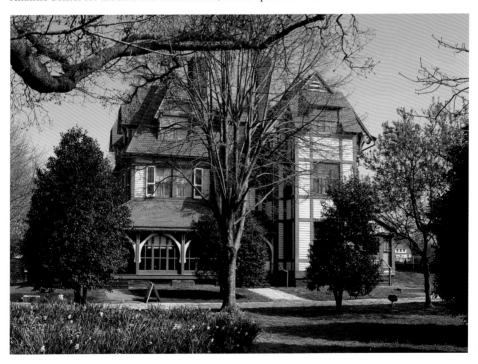

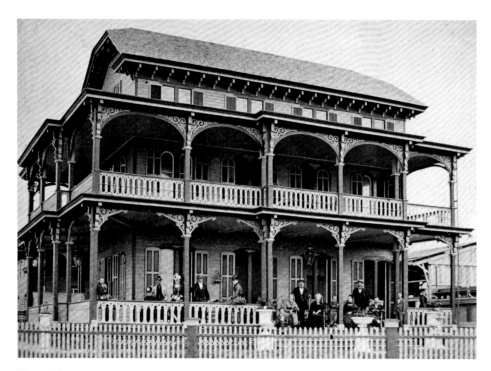

KING HOUSE: A miniature golf course at the foot of Jackson Street occupies the site where Philadelphian William King and his wife, Catherine, built this elegant bracketed cottage in 1877. King was a drug store owner who later became an oil merchant and the size of their house reflects his great wealth. The house burned to the ground one year later in the Great Fire of 1878 and was rebuilt in a different style.

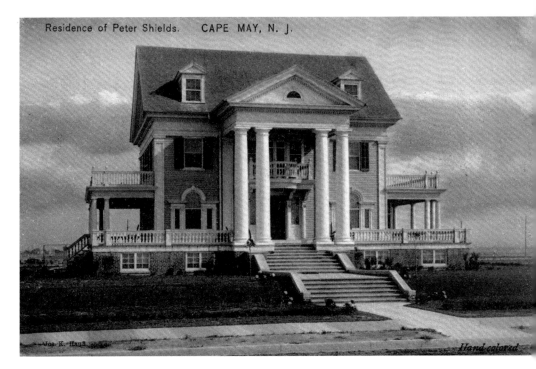

PETER SHIELDS HOUSE: Now a popular restaurant named after its first owner, this Colonial Revival-style house overlooks the Atlantic Ocean from Beach Avenue. It was built in 1906 for Peter Shields, president of the Cape May Real Estate Company, which sought to develop vacant land on the east side of the city. Less successful than anticipated, the company folded in 1915. The house later served as the headquarters of the Cape May Tuna Club in the 1940s.

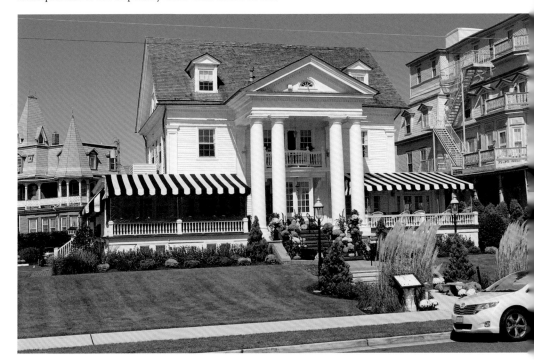

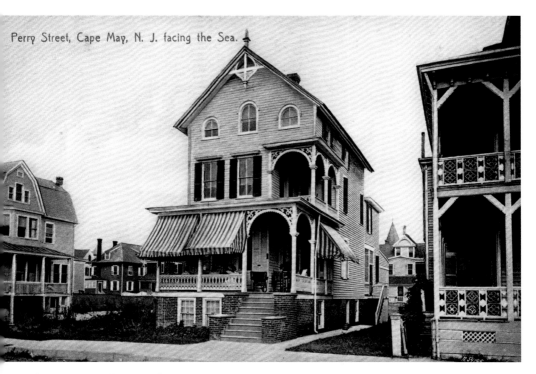

Perry Street, Cape May, N. J. facing the Sea.

COTTAGE AT #11 PERRY STREET: Erected for an unknown client in the early 1900s, this gable-front cottage looks very little like it did when built. Its roof has been shortened, windows changed, doorways moved, and porches expanded and enclosed. On the 1909 Sanborn Insurance map, the building is shown as containing apartments; these were probably rented by the week. Seen to the right is Fryer's Cottage.

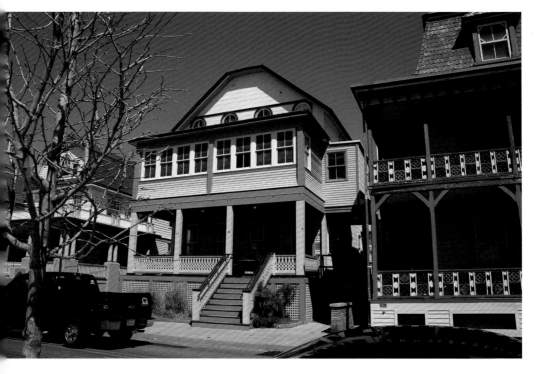

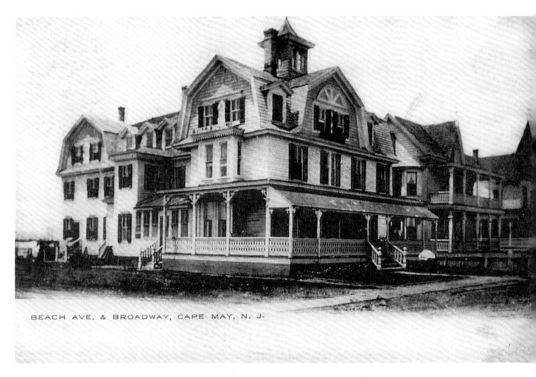

BEACH AVE. & BROADWAY, CAPE MAY, N. J.

VILLA NOVA: Built around 1900 at the west end of the city on Second Street (not Broadway as the postcard erroneously proclaims) near Beach Avenue, this cupola-topped rooming house was probably built for George Rutherford, for many years its proprietor. By 1932, it was known as "Ocean Villa" and the cupola had been removed. The building was demolished in the 1960s and a motel with its parking lot stands in its stead.

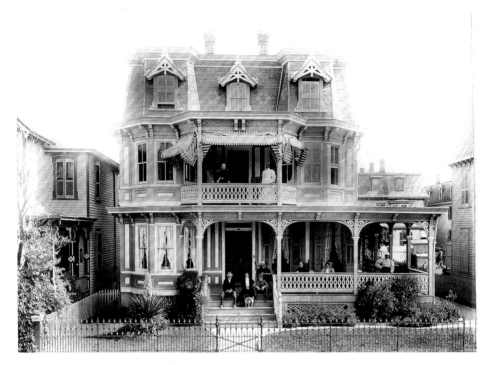

CHRISTOPHER GALLAGHER COTTAGE: Built in 1882-1883 at 45 Jackson Street, this Second Empire-style cottage is nearly identical to the George Hildreth Cottage erected a few months earlier on the same street. Both were designed by local architect and builder Charles Shaw. Gallagher was in the wholesale liquor business and was a partner in the Gallagher & Burton Whiskey Distillers Company located in Philadelphia. The house continues as a private residence.

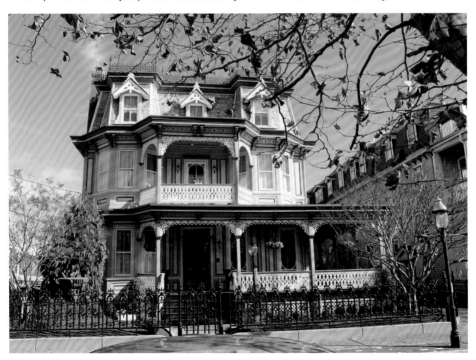

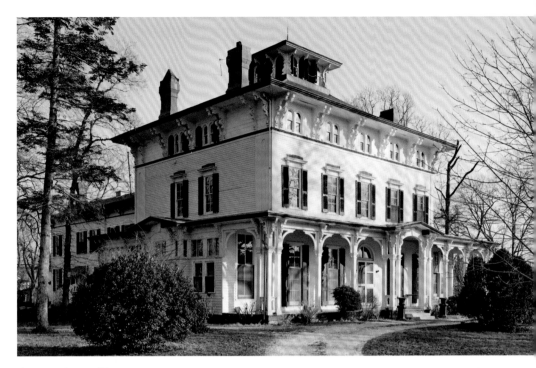

GEORGE ALLEN HOUSE: Philadelphia industrialist George Allen built this house in 1864 on Jefferson Street where it occupies half of a city block between Washington and Corgie Streets. It was designed by Philadelphia architect Samuel Sloan, who later published a design for a nearly identical house in his 1868 book *The Model Architect*. The house remained in the family until 1946, when it was converted into a boarding house. It was restored in the 1990s and is currently a bed-and-breakfast inn.

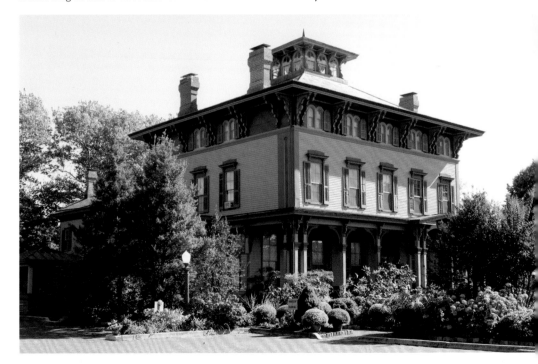

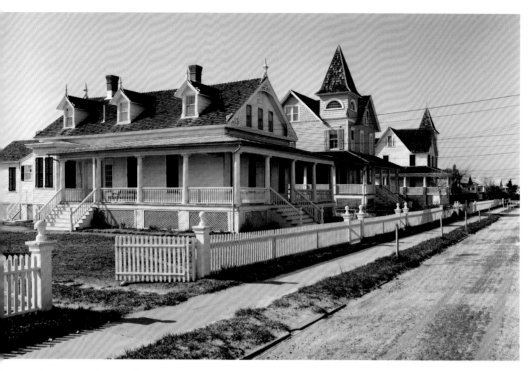

HERZBERG FAMILY COTTAGE: Built about 1900 and seen closest to the camera, this cottage anchors the streetscape on the west side of Broadway at #8. The two houses to its right originally stood in South Cape May, a small resort a dozen blocks to the west established in 1894. Storms ravaged the area and by the 1950s less than twenty buildings remained. These two houses were moved from there around 1954.

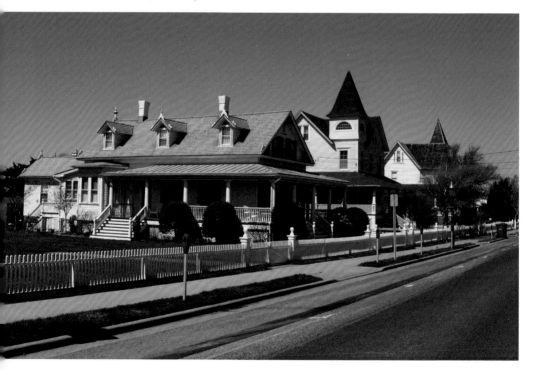

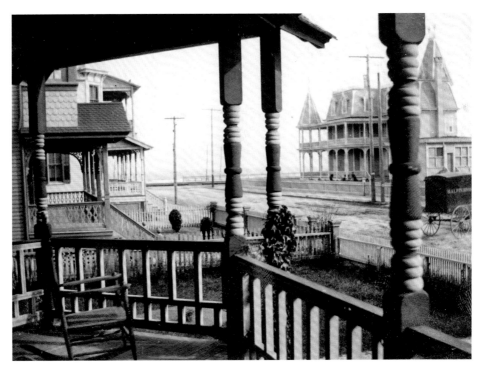

END OF OCEAN STREET: This view looks south from the porch of #23 Ocean Street, which still stands. In the *ca.* 1900 photograph above, Weightman Cottage is seen at the corner of Ocean Street and Beach Avenue before it was moved to its present location in the 1960s. The corner is now occupied by the Marquis de Lafayette Hotel.

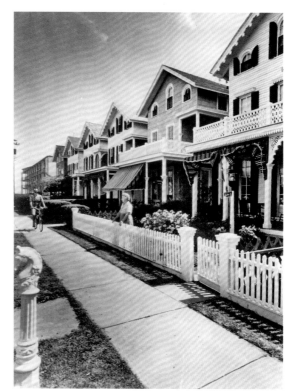

GURNEY STREET COTTAGES: Built in 1872, eight gingerbread-trimmed cottages were designed by Philadelphia architect Stephen D. Button for developers Warne & Sewell, who spent $50,000 erecting them. Although simple in style, the houses were lavished with a wealth of wood ornamentation. The massive Stockton Hotel was located across the street, giving the cottages the name "Stockton Row." Both the Stockton Hotel and the Row barely escaped the Great Fire of 1878.

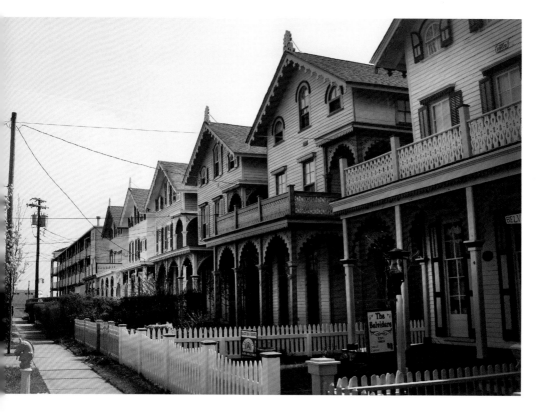

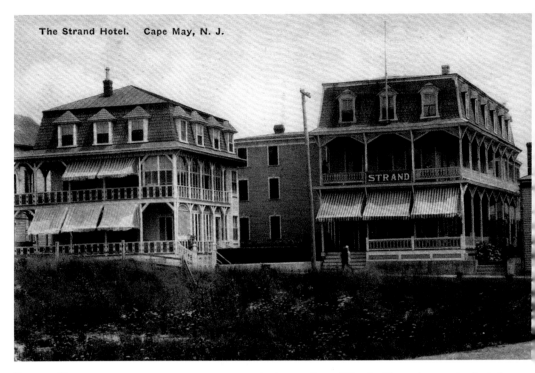

The Strand Hotel. Cape May, N. J.

STRAND HOTEL: Built after the Great Fire of 1878, the former Strand Hotel still stands near the foot of Perry Street. The hotel has had several names over the years and is currently operated as the Sea Villa Hotel. Immediately to its west is Fryer's Cottage, built in 1879; local lore claims the glazed blue and green terra cotta tiles used in its porch balustrade came from the Centennial Exhibition of 1876 in Philadelphia.

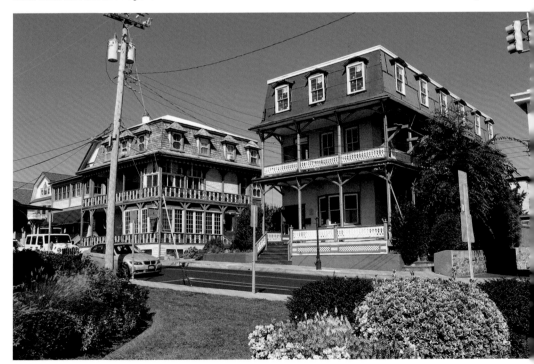

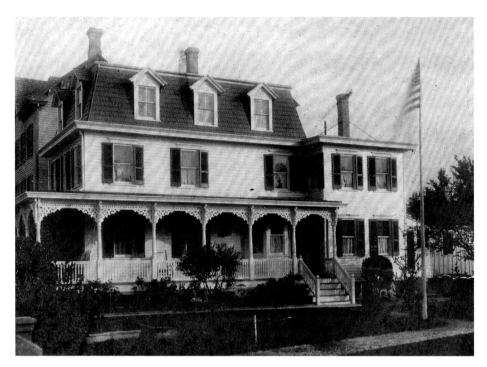

PERRY STREET COTTAGE: Built about 1860 to 1870 at the head of Perry Street near West Perry Street, this mansard-roofed cottage exemplifies the Second Empire style that was so popular in Cape May. During the decade of the 1870s, it was perhaps the most fashionable and widely-built house style. Where Italianate and Gothic Revival styles looked to the past for inspiration, the Second Empire style imitated the latest French architectural designs and was considered very modern.

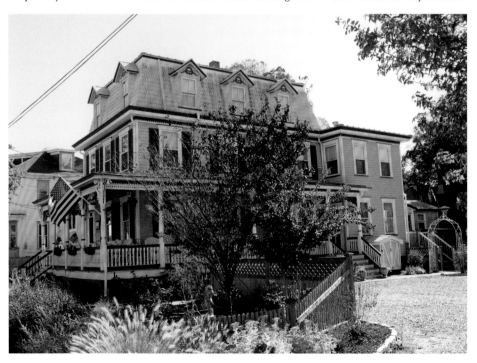

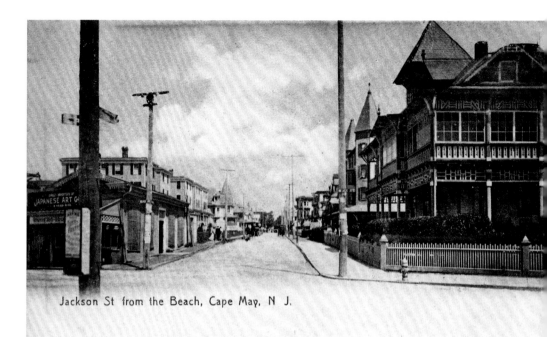

Jackson St from the Beach, Cape May, N. J.

JACKSON STREET FROM BEACH AVENUE ABOUT 100 YEARS APART: A miniature golf course now stands where the William King cottage, rebuilt after the 1878 fire, once stood, and a high-rise condominium stands in place of the twin-towered Baltimore Inn seen behind the King cottage. A. Barsa's Japanese Art store has been either rebuilt or rehabilitated into a modern store and given a second story. Seen in the distance are the Atlantic Terrace houses, which still stand.

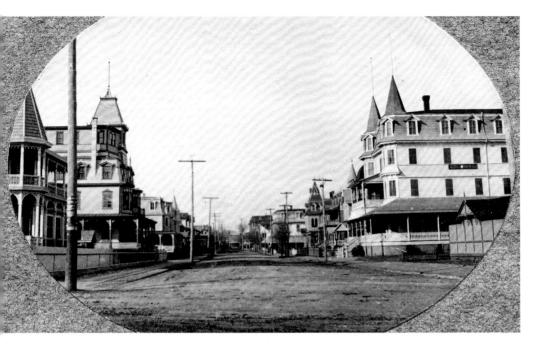

OCEAN STREET FROM BEACH AVENUE: In the *ca.* 1900 photograph, Ocean Street was home to the Weightman Cottage on the corner (left) with Star Villa behind it; both were moved to the east end of Cape May in the late 1900s. On the right, the Colonial Hotel still stands, but was made taller around 1905 when a large wing was added. The spire of Our Lady Star of the Sea Church, built in 1911, appears in the distance of the recent photograph.

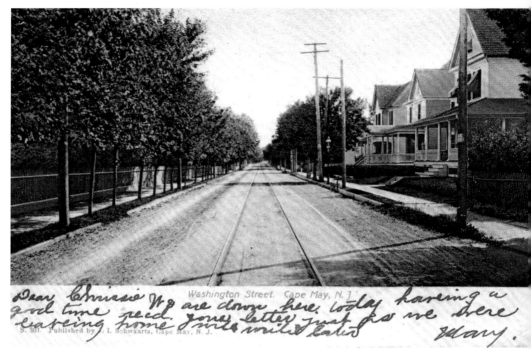

WASHINGTON STREET, LOOKING WEST: Little has changed between *ca.* 1905, the date stamped on the postcard, and today. The original photographer stood just west of the Physick Estate, opposite where the tennis courts are today. The houses seen on the right side of the postcard still stand and most retain their original historic appearance. Horse-drawn trolley service to Schellenger's Landing, the tracks of which are seen in the postcard, began in the early 1880s.

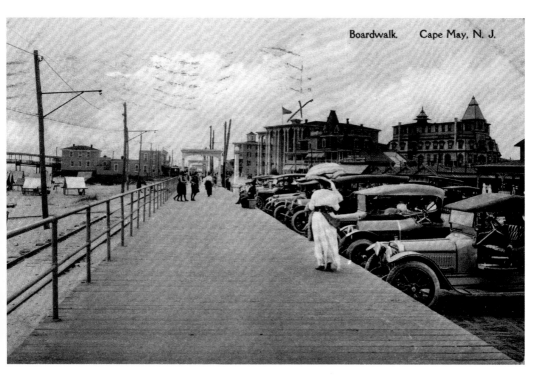

Boardwalk. Cape May, N. J.

VIEW WEST DOWN THE BOARDWALK: The "X" on the *ca.* 1920 postcard marks the Lafayette Hotel, built in 1884 and demolished in 1970. Seen next to it is the Star Villa, which faced onto Ocean Street; it was moved to the 1400 block of Beach Drive in the 1960s. Iron Pier, seen to the left in the postcard, was built in 1884 and featured shops at its entrance at the foot of Decatur Street.

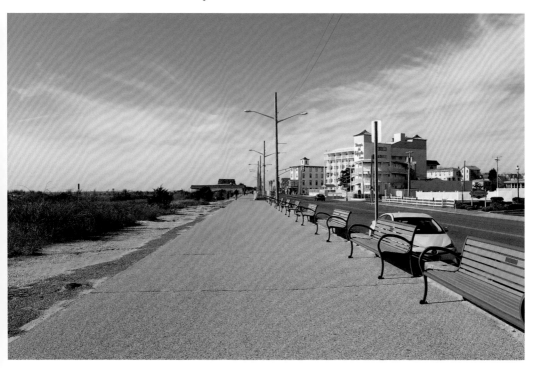

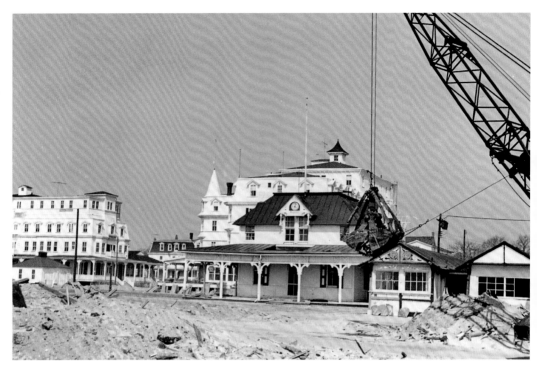

Foot of Ocean Street at Beach Avenue: A devastating nor'easter in March 1962 was one of the worst storms to hit Cape May in the twentieth century. Sand and debris was piled high near the foot of Ocean Street. The five-story tall Colonial Hotel in the center of the storm photograph still stands, but the metal roof covered bath house office and short bath houses in front of it have long since been torn down.

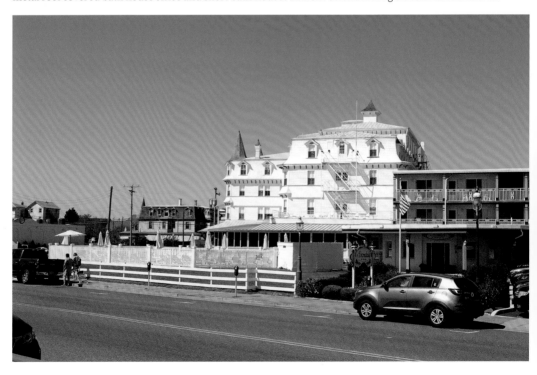

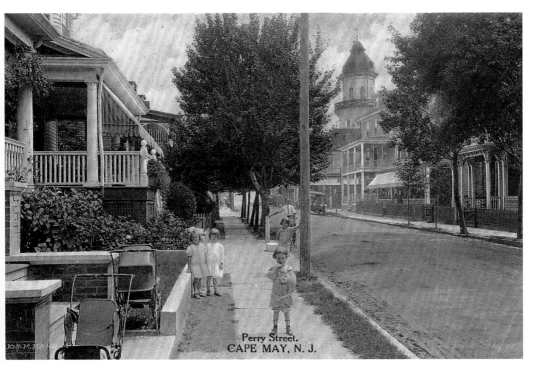

PERRY STREET, LOOKING SOUTH: Most of the houses and boarding houses seen in the *ca.* 1920 postcard still stand. The 85-foot tower atop the Congress Hall garage at the corner of South Lafayette Street was the top of the 1875 Sea Grove pavilion in nearby Cape May Point. It was purchased at auction for $400 in 1882 and became a landmark for ships at sea. The garage has been replaced with a modern motel.

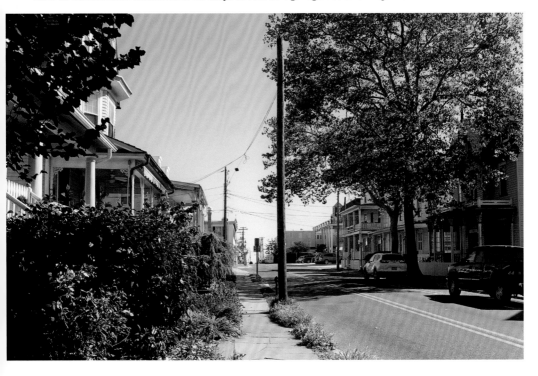

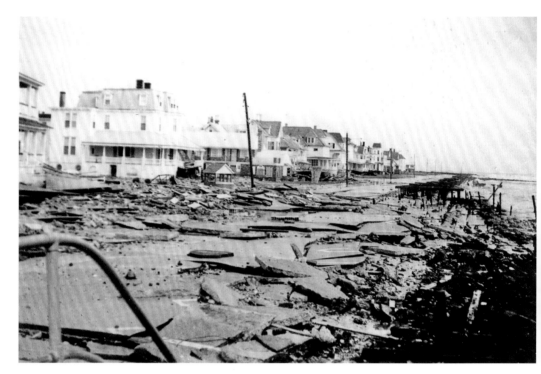

HOWARD STREET AND BEACH AVENUE: The three-day March 1962 nor'easter packed winds up to 60 miles per hour, devastating the Cape May shoreline. The boardwalk's boards were ripped from their pilings, concrete streets were heaved, and sand piled up against the houses. The city recovered and the houses along with the two-story motel seen in the 1962 photograph still stand, facing the ocean.

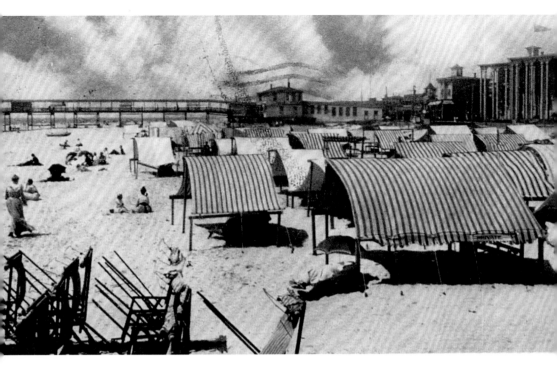

ON THE BEACH NEAR THE CONVENTION CENTER: The *ca.* 1920 postcard view looks west towards the Iron Pier, built in 1884 at the foot of Decatur Street. It hosted concerts, dances, and other entertainment, but was torn down in the twentieth century. The grand Lafayette Hotel, seen to the far right, has been replaced with the modern Marquis de Lafayette Hotel. Beach goers today use umbrellas instead of the striped tents popular around the turn of the last century.

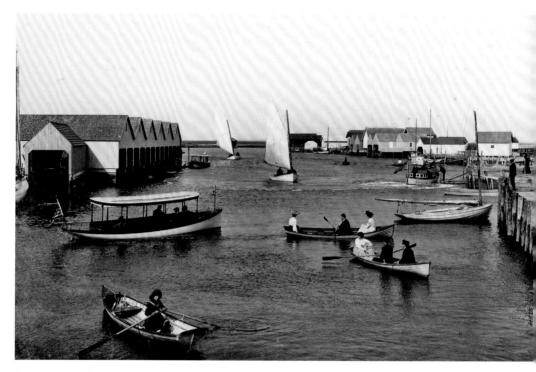

SCHELLENGER'S LANDING: Located at the head of Washington and Lafayette Streets, Schellenger's Landing on Cape Island Creek was home to Schellenger's Hardware Store in the late 1800s and later became a popular place to hire a pleasure boat. The area has been greatly developed and offers docks for sightseeing boaters, commercial fishermen, and sport fishermen. Few historic buildings remain here.

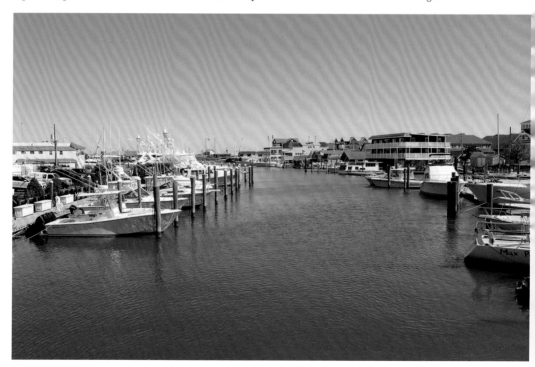

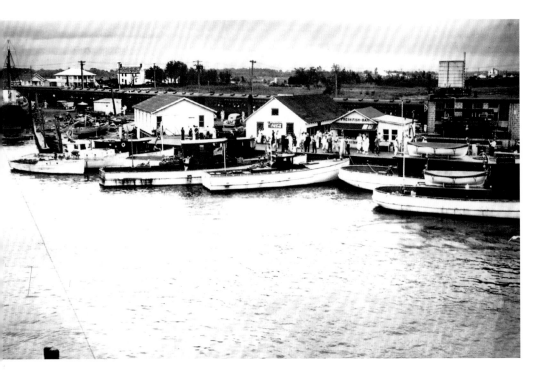

SCHELLENGER'S LANDING, LOOKING NORTH: The *ca.* 1940 photograph, above, shows the north side of Cape Island Creek where tourists arrived by the "Fishermen's Special" train to hire a boat for sightseeing or fishing every Thursday, Saturday, and Sunday during the season. Today, the popular restaurant, The Lobster House, and the fleet of commercial fishing boats that consider the port of Cape May home, are located here.

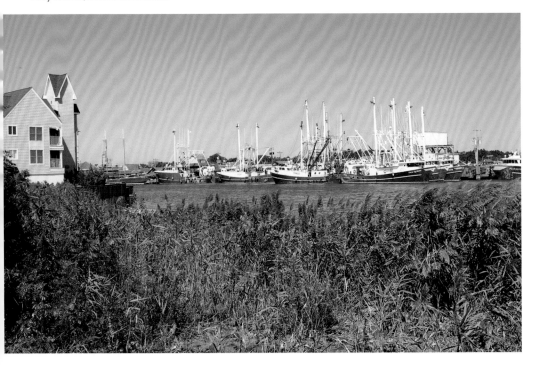

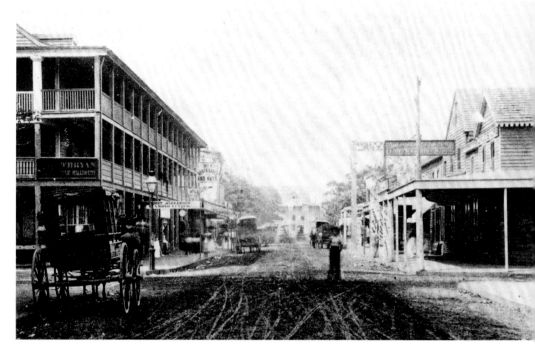

WASHINGTON STREET AT DECATUR, LOOKING WEST: This view shows the city's busy commercial district. In the late 1800s, both sides of the street were lined with stores just as they are today, with Congress Hall standing at the far end where Washington Street terminates at Perry. Businesses then included diamond cutter Henry Alexander, milliner Mrs. O'Bryan, druggists Kennedy and Son, and jeweler C. M. Leeds, among others. Businesses today include restaurants, candy and gift shops, and clothing stores.

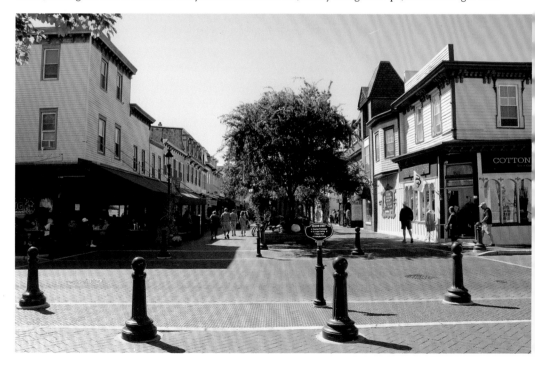

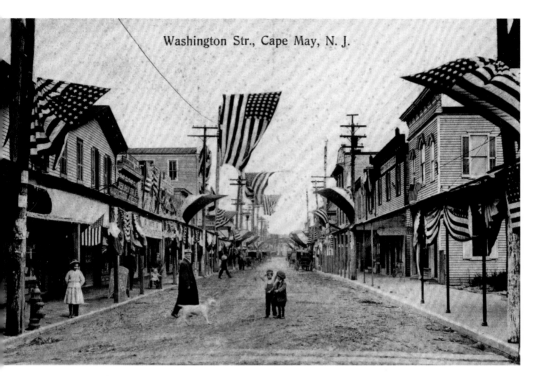

Washington Str., Cape May, N. J.

WASHINGTON STREET AT PERRY, LOOKING EAST: Although many of the buildings seen in the *ca.* 1908 postcard still stand, most have been altered from their original appearance, particularly along the roof line. This view shows the western terminus of what is today known as the Washington Street Mall, still the heart of the city's bustling commercial district. Congress Hall stands behind the photographer.

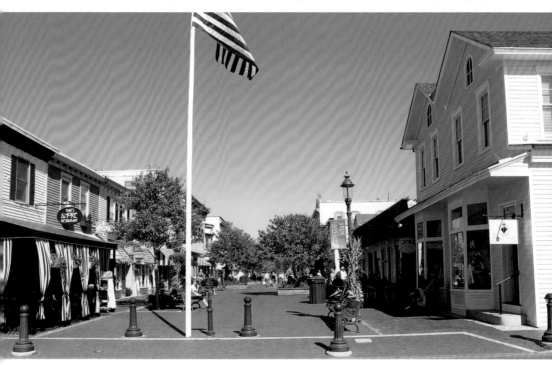

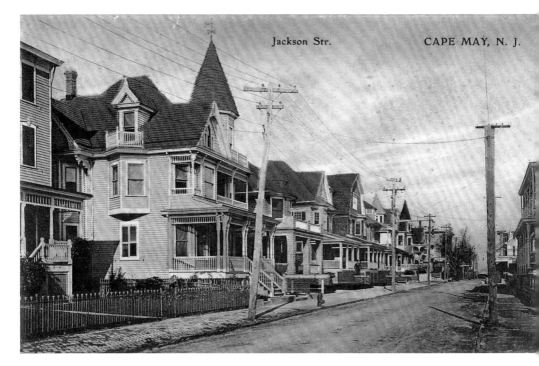

JACKSON STREET, LOOKING WEST: After the New Columbia Hotel between Jackson and Perry Streets burned to the ground in 1889, its site was sold off into building lots for summer cottages. Most were erected in the Queen Anne style for which the city has become famous, featuring gingerbread-trimmed porches, steeply pitched roofs, and the occasional tower. At the far left is one of the seven Atlantic Terrace houses built in 1892.

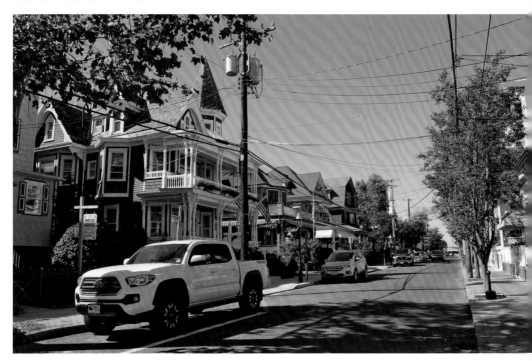

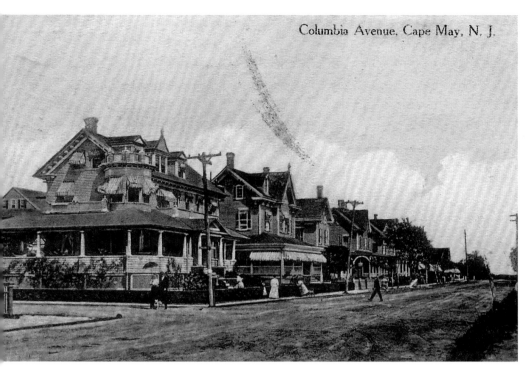

COLUMBIA AVENUE AT STOCKTON PLACE, LOOKING EAST: Beginning in 1869 and ending in 1886, the north side of Columbia Street between Stockton Place and Franklin Street was fully built out with eight summer cottages that stood behind the Stockton Hotel, erected in 1869. In the *ca.* 1910 postcard, above, the blocks beyond were vacant land that would not be built upon until the early 1900s.

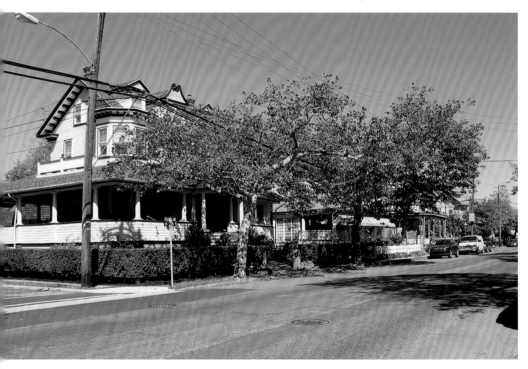

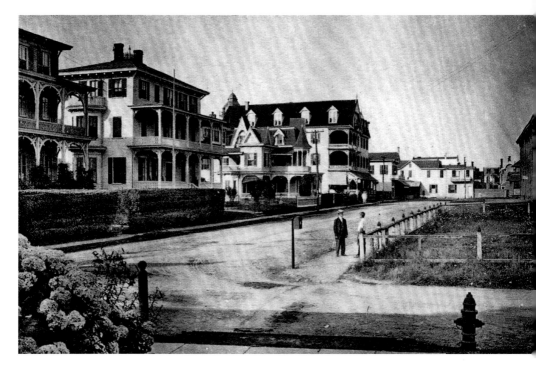

CONGRESS PLACE: This one-block-long street behind Congress Hall was a fashionable address in the early 1900s. The first two houses on the left were built for E. C. Knight and Joseph Evans in the winter of 1881-1882 and are attributed to Philadelphia architect Stephen D. Button. The shorter cottage is the Dr. Henry Hunt House, built about the same time. The three-and-one-half-story Elberon Hotel beyond the Hunt House was torn down and is a modern motel.

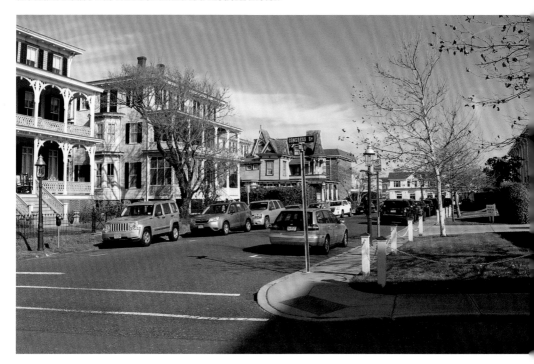

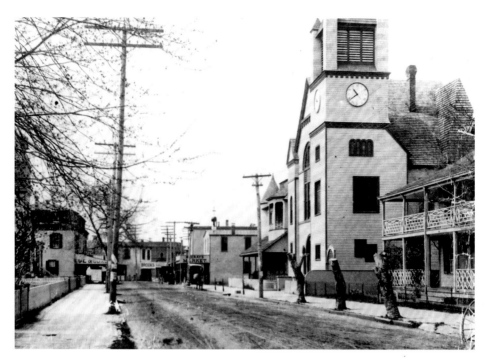

WASHINGTON STREET, LOOKING WEST: The Methodist Episcopal Church, seen at the right, was built in 1844 as the Presbyterian Visitor's Church. It was renovated around 1867 and remodeled again in 1893 to the exterior seen in the *ca.* 1900 postcard above. The church was remodeled in the 1970s to its present appearance. None of the neighboring buildings seen in the historic photograph still stand; those opposite the church were razed in the 1960s for construction of the Victorian Towers apartment complex.

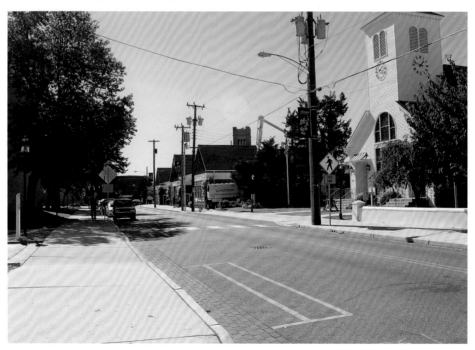

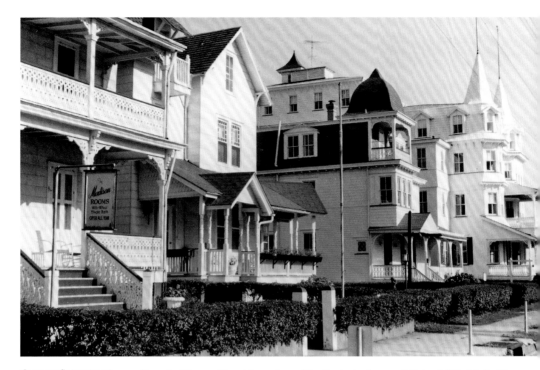

OCEAN STREET: The south end of Ocean Street is anchored by the twin-towered Colonial Hotel, built in 1894 on the east side of the street. The cottages seen here were erected to replace four lost in the Great Fire of 1878. The 1961 photograph, above, shows the cottages before they were restored to their original appearance with the removal of modern siding, replication of gingerbread trim, and painting in historically appropriate colors.

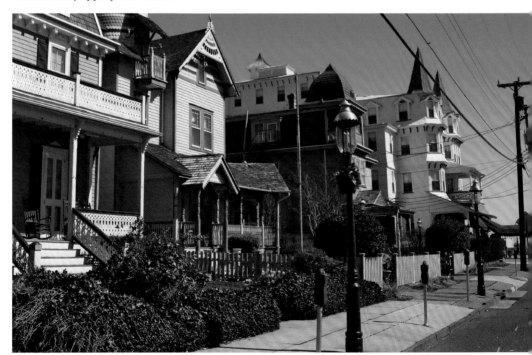

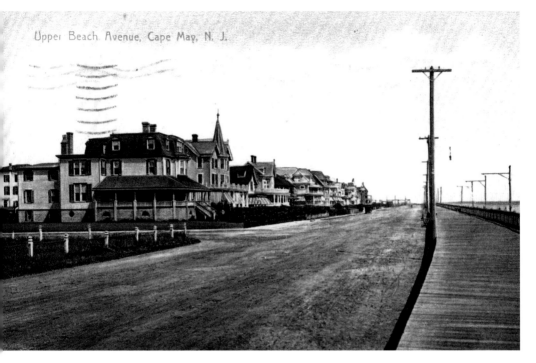

Upper Beach Avenue, Cape May, N. J.

BEACH AVENUE EAST OF JEFFERSON: Vacant waterfront property beyond Jefferson Street was developed beginning in the late 1800s and early 1900s. The *ca.* 1920 hand-colored postcard, above, shows the cottages were built in the popular styles of the day, including Colonial Revival, Dutch Colonial Revival, and American Foursquare. Most featured dormers to cool and bring light into attic bedrooms along with two-story porches that capitalized on their views of the ocean.

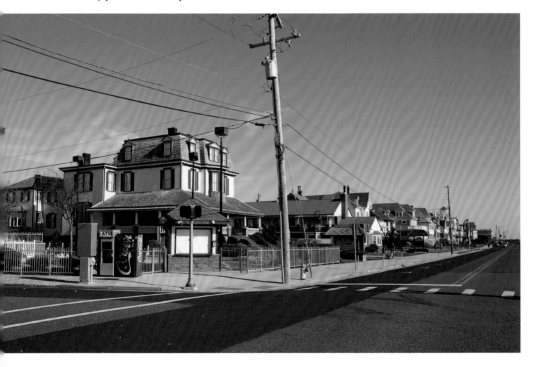

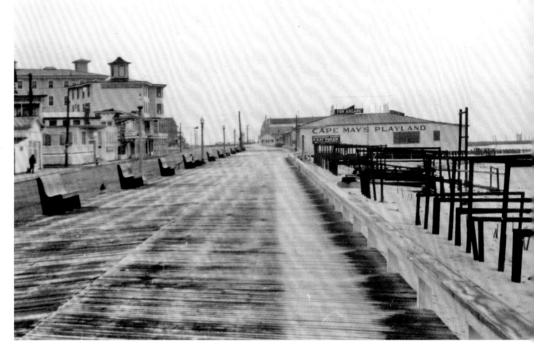

BOARDWALK NEAR JACKSON STREET: Around 1880, Victor Denizot built the Ocean View Hotel (later Arnold's Hotel) with its distinctive angled walls, bay window, and cupola-topped roof, seen at left in the *ca.* 1960 photograph. Cape May's Playland opposite the hotel was originally the entrance to the Iron Pier that Denizot also built; neither remains standing. Seen in the distance is the 1917 Convention Hall.

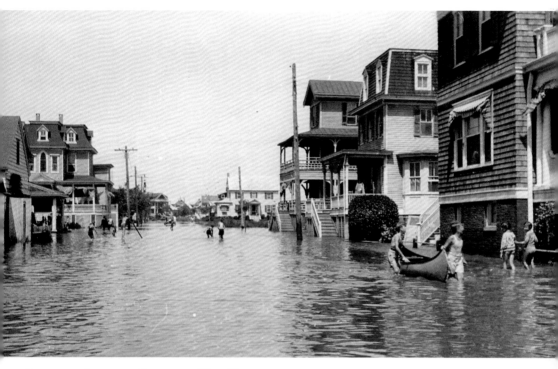

JEFFERSON STREET AT STOCKTON, VIEW NORTH: The weather was warm enough after the September 1944 hurricane that children could paddle canoes and wade in the water-covered streets in their summer clothes. In addition to flooding the city, the hurricane tore up the boardwalk and wrecked Convention Hall. Most of the houses seen in the 1944 photograph survived the deluge; they date from the late 1800s, when this part of Jefferson Street was developed.

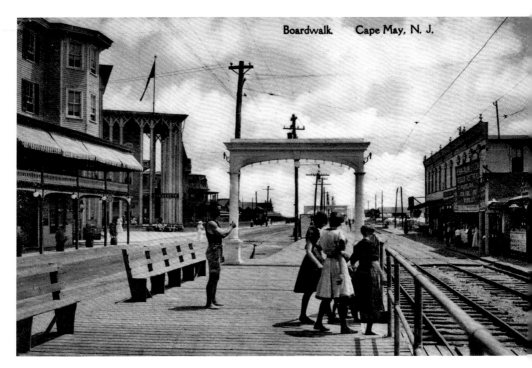

Boardwalk. Cape May, N. J.

BOARDWALK AT JACKSON STREET, VIEW EAST: The former Ocean View Hotel, seen at the left in the *ca.* 1914 postcard above, stills stands, but the pillared Lafayette Hotel to its east was demolished in 1970 and replaced with the Marquis de Lafayette Hotel. The lighted boardwalk arches were part of an early twentieth-century beautification project. The tracks next to them carried passengers on the Cape May, Delaware Bay & Sewell's Point Railroad trolley east to Sewell's Point.

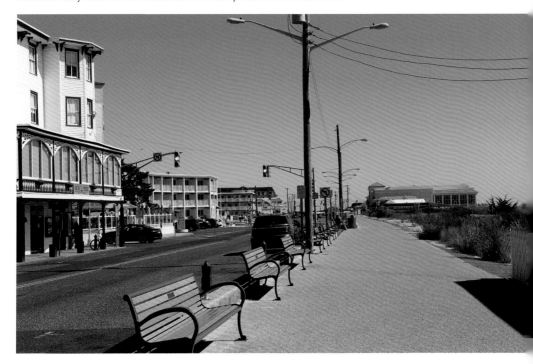

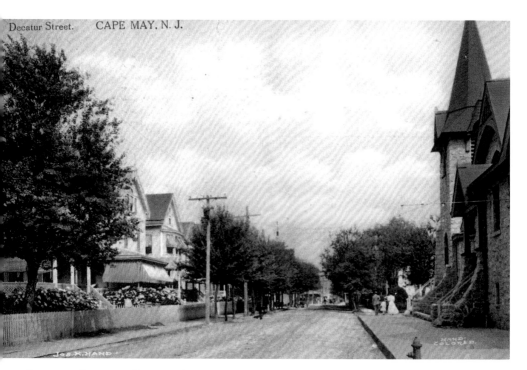

Decatur Street. CAPE MAY, N. J.

DECATUR STREET AT HUGHES, LOOKING NORTH: The Cape Island Presbyterian Church, seen at the right, was built in 1898. It is the congregation's third house of worship and stands on land previously occupied by the Columbia Hotel which burned in 1878. The congregation previously worshipped on Washington Street in the building now serving as the Methodist Episcopal Church. The houses opposite the church date to the 1880s and retain most of their original Queen Anne style details.

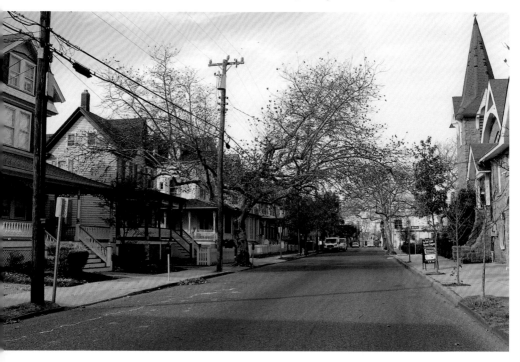

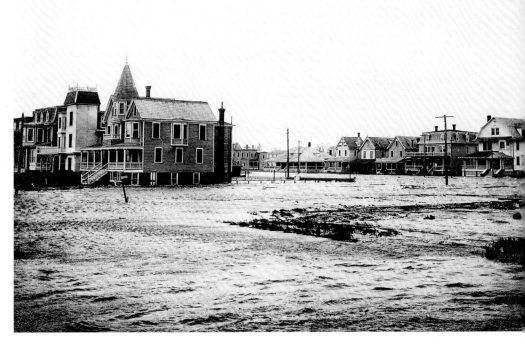

BEACH AVENUE AT QUEEN, LOOKING NORTHWEST: A storm in the early 1900s brought flooding to Cape May, particularly affecting cottages along Beach Avenue. Flooding was common in coastal storms, with water lapping against foundations. The house with the tower contained apartments rented during the summer in the opening decades of the twentieth century. The cedar-shingled house at the corner and the two next to it along Queen Street were built in the 1920s.

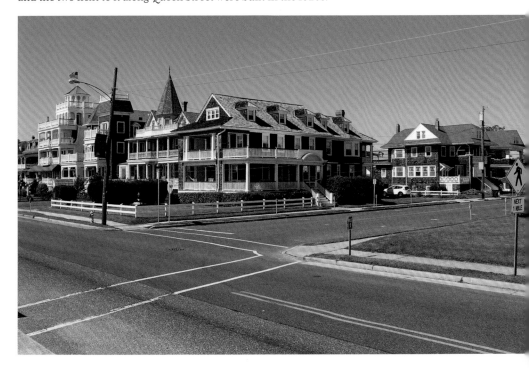

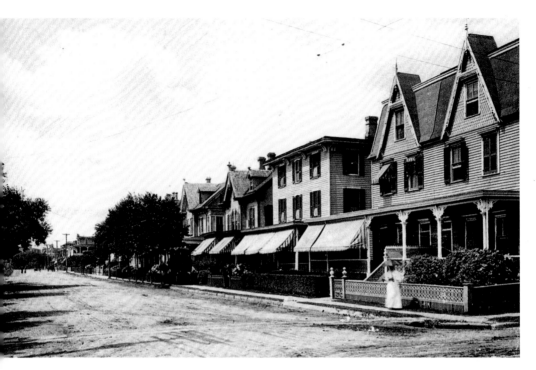

COLUMBIA AVENUE AT FRANKLIN, LOOKING WEST: Developers Bullitt & Fairthorne created this street in 1866 after purchasing and updating the Columbia Hotel at what was then Columbia Street's west terminus at Ocean Street. Another developer, Peter McCollum, built and sold two of the cottages seen here: the twin-gabled double house at the corner (#731-733) and the center-gable cottage (#725) two houses away. All of them still stand.

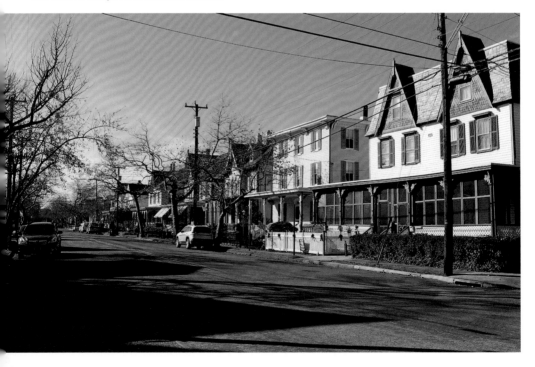

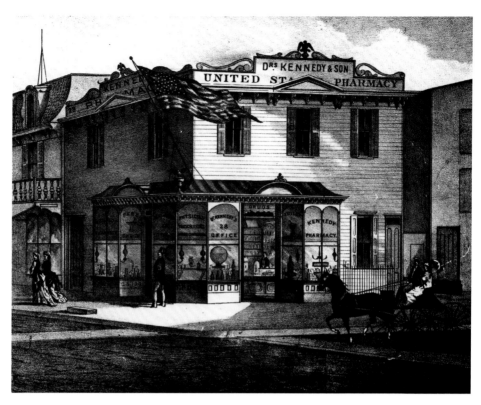

KENNEDY'S DRUG STORE: Dr. James Kennedy opened the city's first drugstore in 1843. About 1873, he and his son, Henry, built the United States Pharmacy at the corner of Washington and Decatur Streets where the building still stands, although altered from its original appearance. The structure also contained their offices and was named for the United States Hotel which stood catty-corner from this location but burned down in 1869. The drawing above shows the drug store's appearance in 1878.

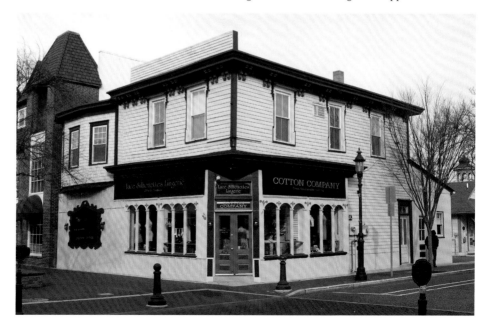

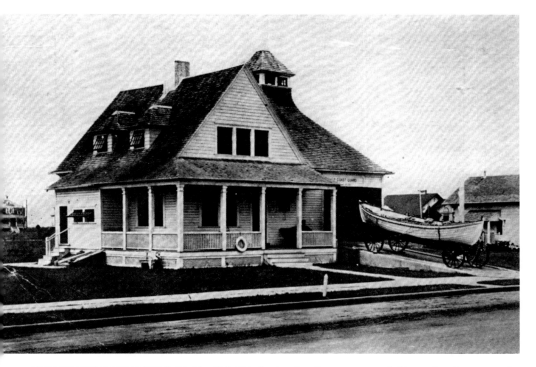

FORMER LIFESAVING STATION: The U.S. Life Saving Service constructed this station, known as the Cold Spring Station, at #1111 Beach Avenue for $7,000 in 1890. The photograph above was taken about 1920. The station's design is referred to as Bibb #2 type, so called for architect Albert Bibb who designed twenty-two stations, nine of which were built along the Jersey shore between 1886 and 1891. This one became the first Kiwanis-owned clubhouse in the United States in 1937.

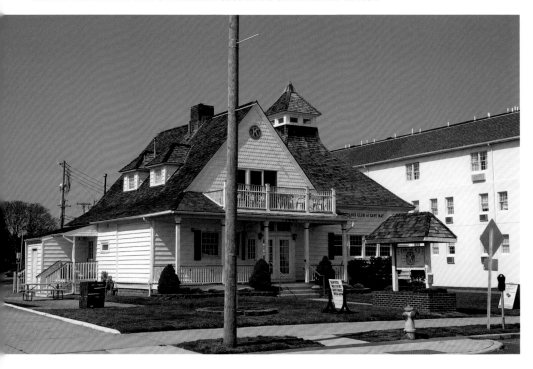

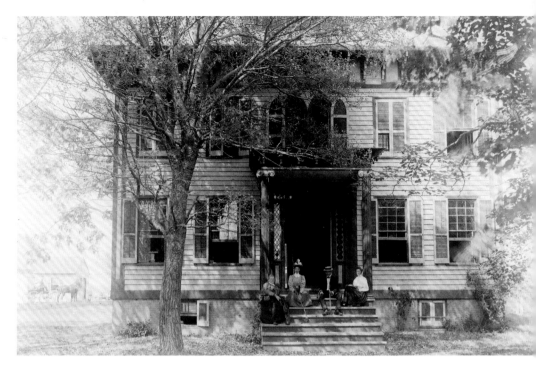

CAPE MAY GOLF CLUB: In 1897, local cottager Dr. Emlen Physick helped organize the Cape May Golf Club, and its eighty-plus members built a nine-hole golf course on Lafayette Street. The Club bought Thomas Wales' 40-acre farm for their course and converted Wales' *ca.* 1860 three-story Italianate Villa-style house into their clubhouse. The club failed in the 1940s and the structure is once again a private residence, but is missing its original cupola, chimneys, and front porch.

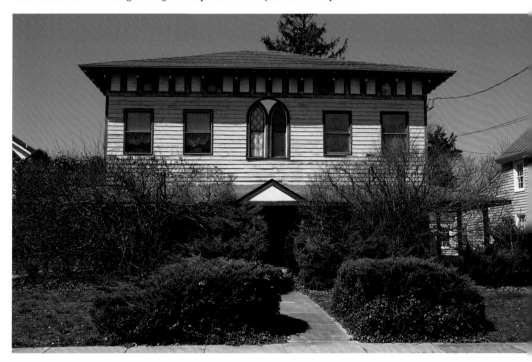

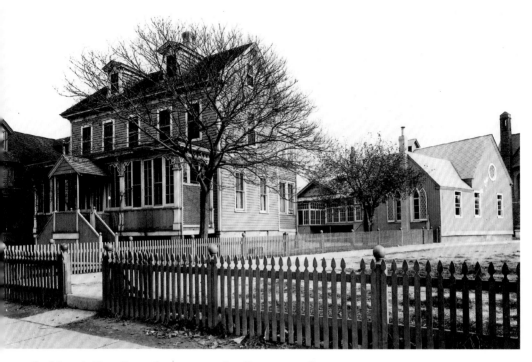

St. Mary's/Our Lady Star of the Sea Parochial School: After erecting a new church near the corner of Washington and Ocean Streets in 1914, the Roman Catholics moved their original 1848 parish to stand behind the new one as seen in the *ca.* 1920 photograph above. The *ca.* 1860 house that faced Lafayette Street behind the old parish was used as the parochial school for a number of years; it also reportedly served as a convent.

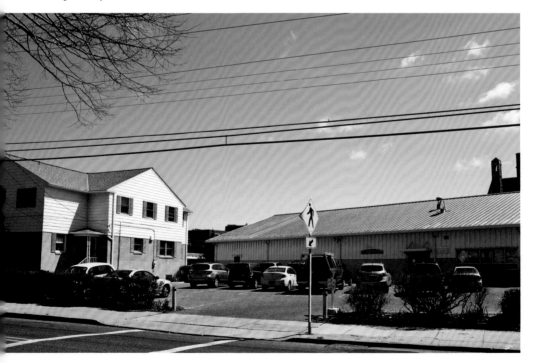

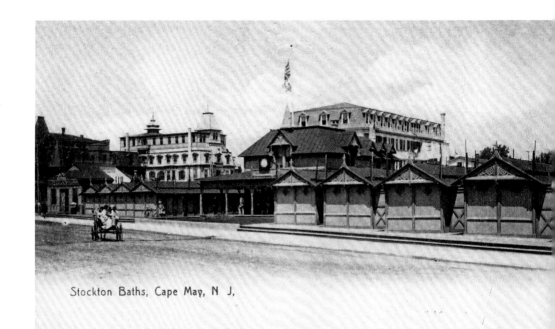

Stockton Baths, Cape May, N J,

A. W. Hand, Cape May, N. J.

STOCKTON BATHS: Built in the late 1870s, the Stockton Hotel bathhouses were located on Beach Avenue between Ocean and Gurney Streets. They flanked a two-story pavilion that provided a gathering place for swimmers and walkers alike. Clotheslines placed on top of each proved a handy place to dry the heavy, knit wool bathing suits. For years, the bathhouses were painted yellow with brown trim and sported red tin roofs. Most were demolished in the 1960s.

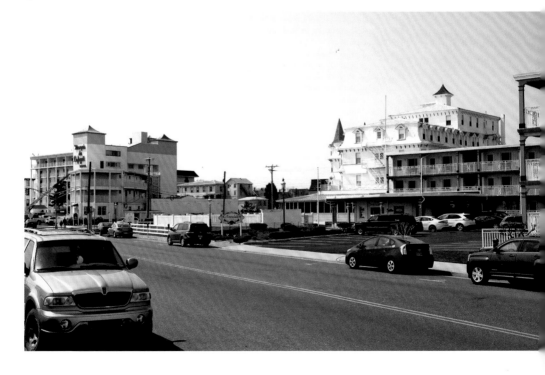

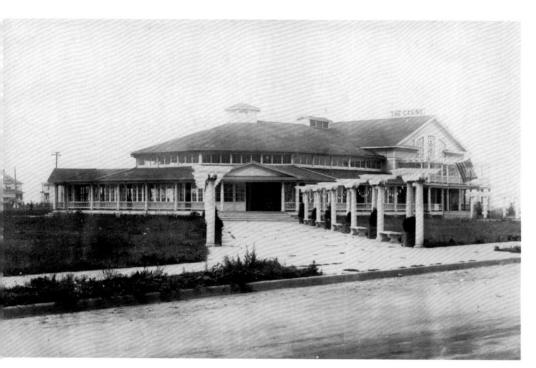

MARINE CASINO: Built in 1913 on the former Marine Villa lot at the corner of Howard Street and Beach Avenue, the casino was an octagonal building with a spacious dance floor and merry-go-round, among other amusements. It was erected by developer Nelson Z. Graves as a way to rejuvenate the failing New Cape May project that he had taken over. Dances were often held by subscription, with cottagers paying a set fee per week to reserve the dance floor.

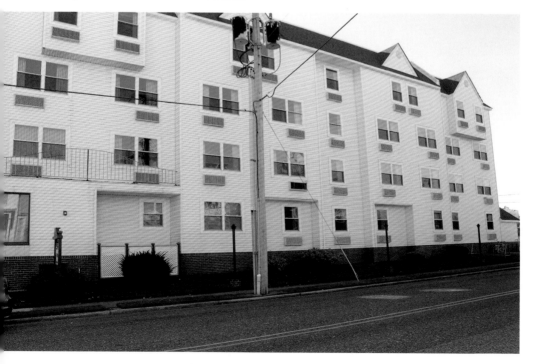

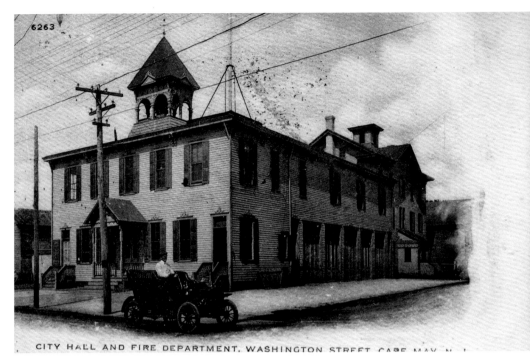

CITY HALL AND FIRE DEPARTMENT, WASHINGTON STREET, CAPE MAY, N.J.

CITY HALL: Erected in 1899 at the corner of Washington and Franklin Streets next to the 1867 Franklin Street School, this city hall replaced an earlier municipal building at the same location. The new building also contained the fire department (note the five tall doors for the fire apparatus in the *ca.* 1910 photograph above), the police station, and the municipal court. The structure was torn down in 1970, and today the site is occupied by the fire museum.

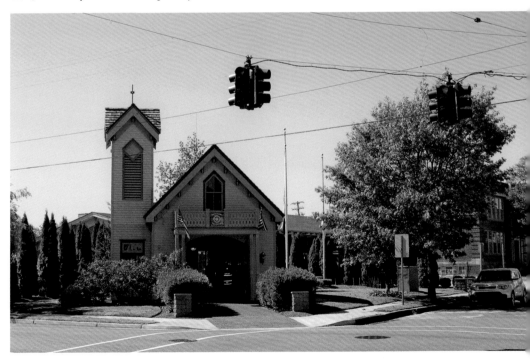

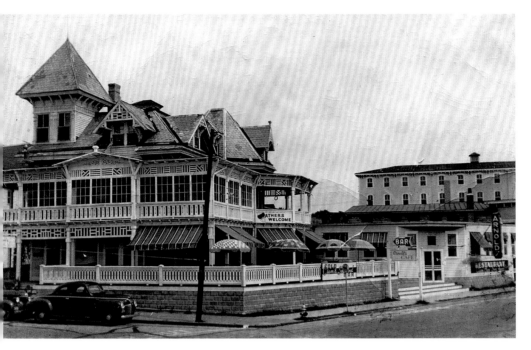

ARNOLD'S CAFÉ: This impressive cottage, located at the corner of Jackson Street and Beach Avenue, was erected about 1880 by William King, who owned the Excelsior Baths next door. King's first cottage burned to the ground in the Great Fire of 1878. Charles Arnold, a former hotel clerk, operated a café here in the 1920s, serving steaks, seafood, and beer before Prohibition. Seen in the background, right, is the Lafayette Hotel. A miniature golf course now occupies the site.

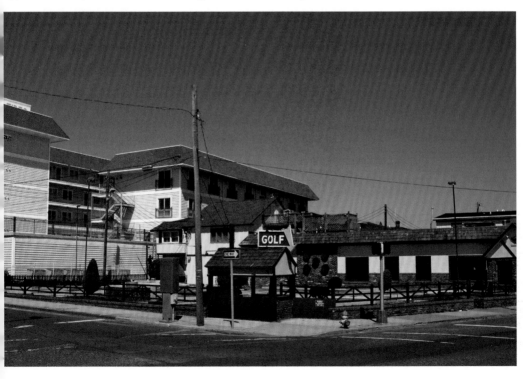

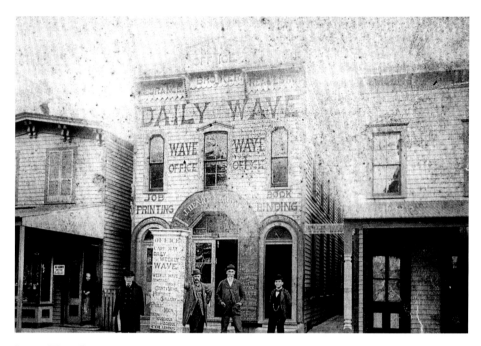

DAILY WAVE BUILDING: The city and county's first newspaper was founded in 1854 as a weekly paper. By 1876, it published a daily summer edition known as the *Cape May Daily Wave*. The newspaper's office, seen in the center above, was located at #512 Washington Street in a commercial building owned by insurance agent and real estate broker J. Henry Edmunds, who purchased the paper in 1886. It still stands, but has been greatly altered.

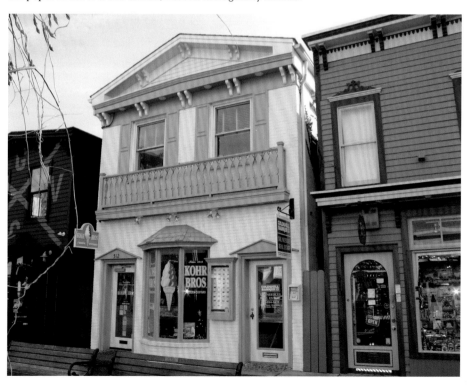

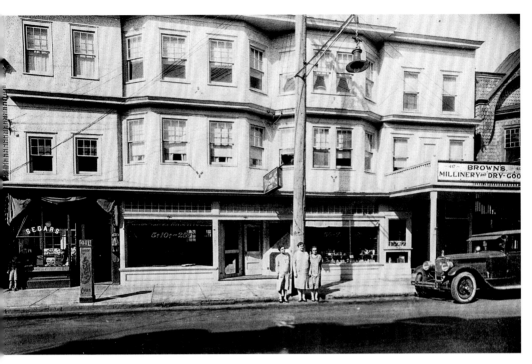

COMMERCIAL BUILDINGS ON WASHINGTON STREET: In the 1920s and 1930s, Laura Brown operated a millinery and dry goods store at 417 Washington Street. According to numbers painted on the storefront windows, she sold items that ranged from 25¢ to $1.00. Next door to the west at #411 was Freddy's cigar store, complete with a carved Indian plaque mounted by the door as an advertisement of his wares. The four-unit row no longer stands and has been replaced with separate buildings.

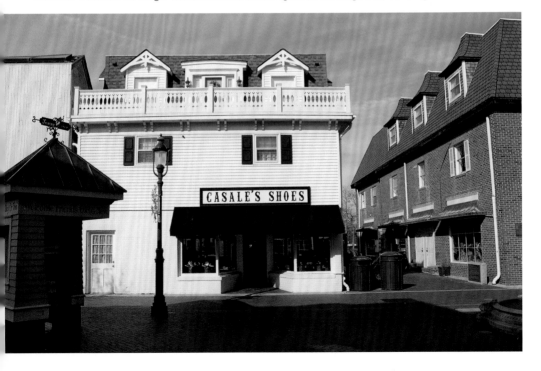

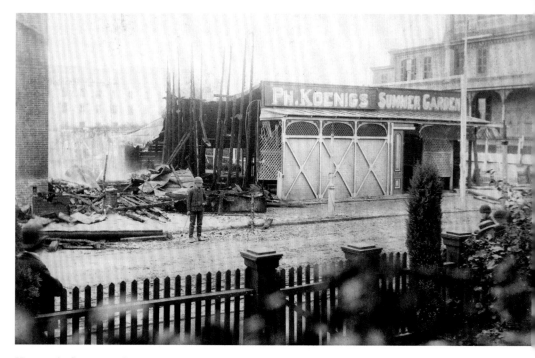

KOENIG'S SUMMER GARDEN: Philip Koenig operated a popular beer garden on Jackson Street, immediately behind the New Columbia Hotel. The hotel burned to the ground in late September 1889 and heavy rains helped city firemen prevent the flames from traveling to many other buildings. However, Koenig's establishment was heavily damaged. No lives were reported lost; the hotel and presumably the beer garden were largely vacant, the summer season having ended a few weeks earlier. Houses now occupy the site.

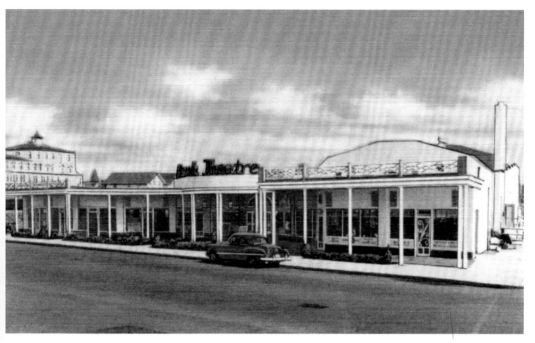

BEACH THEATRE, BEACH AVENUE: The movie theatre opened on June 29, 1950, with 800 seats and the movie "The Father of the Bride." It was built by local entertainment mogul William Hunt who owned many area resort theaters. Philadelphia architect William H. Lee won a national architectural award for his design. The theatre closed in 2007 and in 2011 its auditorium was demolished to make way for condominiums which have yet to be built. However, the storefronts were retained.

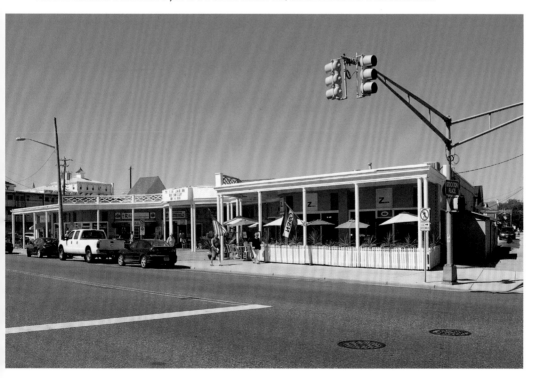

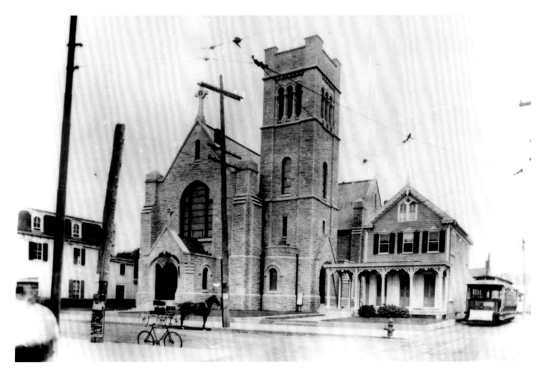

OUR LADY STAR OF THE SEA: Built about 1915, this grandiose gray granite structure replaced the congregation's earlier Catholic chapel, built in 1848 and located on this prominent site at the corner of Washington and Ocean Streets. It was designed by George Lovatt, a noted architect responsible for many important Catholic churches in Philadelphia. The 1848 bell still chimes from the tower of the new building.

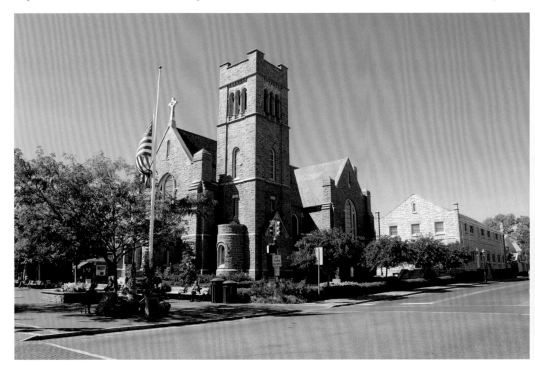

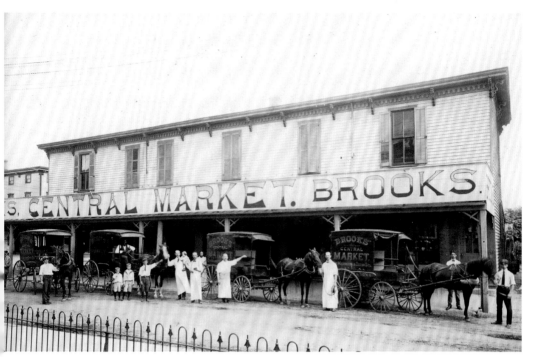

BROOKS CENTRAL MARKET: Located at the busy corner of Washington and Ocean Streets, this grocery store made home deliveries with a fleet of horse-drawn carriages. Grocer Joseph Brooks operated the business around the turn of the last century; it later became McCray's Market. The building stood nearly opposite the Washington Street passenger station of the Reading Railroad. The Victorian Towers apartment complex, built in the early 1970s, stands on the site today.

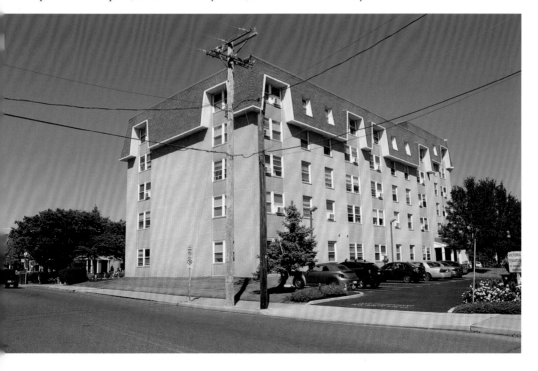

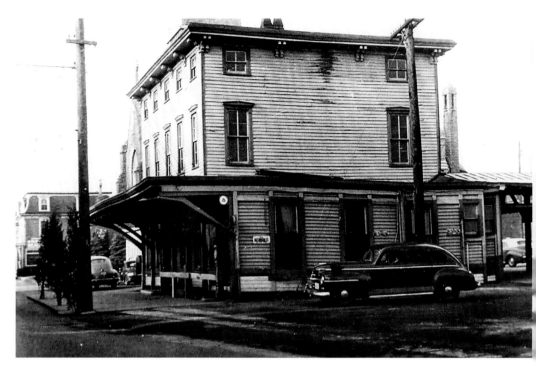

READING RAILROAD TRAIN STATION: Located on the north side of Washington Street, the Reading station was built in 1894 when a second rail line to service Cape May was established. Tracks of the two competing lines often ran parallel and when in sight of each other, the trains held informal races to see which would arrive first. As car travel became popular, business waned and the two were forced to merge in 1933, creating the Pennsylvania-Reading Seashore Line. A small modern shopping center occupies the site today.

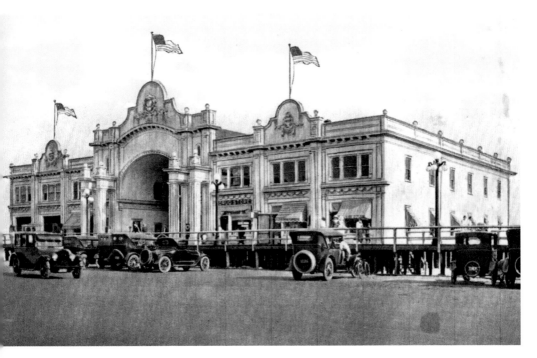

CONVENTION HALL: Completed in time for the 1917 season, Convention Hall was built on the beach at the terminus of Stockton Place. It featured a movie theater, an auditorium for band concerts, several stores, and a billiards room. Behind it was a long fishing pier over deep water that was a favorite with anglers. Damaged beyond repair in the 1962 nor'easter, it was replaced in 1965. The 1965 building was then replaced with the current one in 2012.

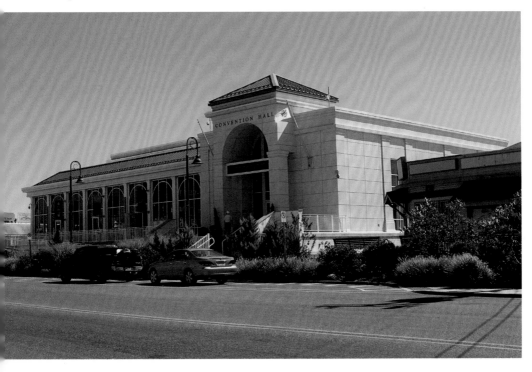

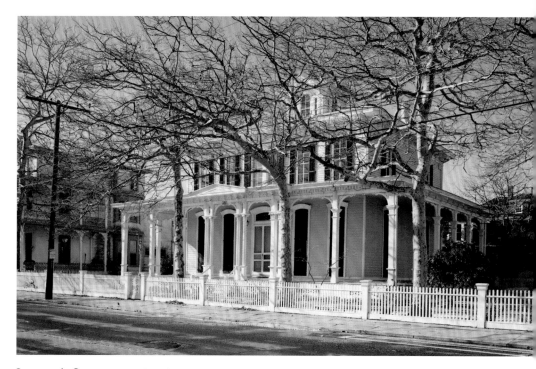

JACKSON'S CLUBHOUSE: This elegant building was erected as a gentleman's gambling establishment in 1872 at the corner of Columbia Avenue and Stockton Place. The cupola-topped structure hosted games of chance until the 1880s, when it became a private home. By the mid-1900s, it was called the Victorian Mansion and offered guest rooms. In 1977, it was beautifully restored and became the Mainstay Inn, the city's first bed-and-breakfast inn, a use that continues today.

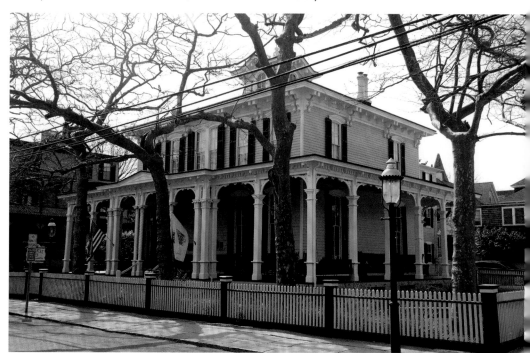

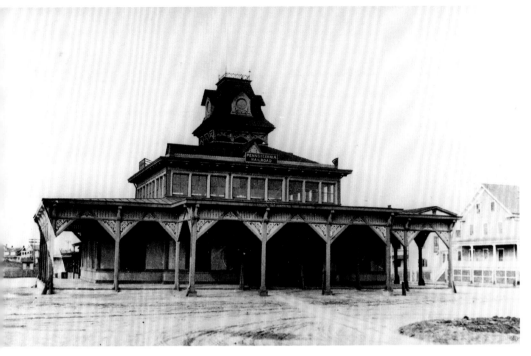

PENNSYLVANIA RAILROAD STATION: The first railroad connecting Cape May and Philadelphia via Camden was completed in 1863 and passengers arrived or departed from this building erected by the Pennsylvania Railroad in 1876. Known as the "summer station" since it was only used during the summer season, the depot cost $20,000 and stood on Beach Avenue next to Grant Street. At that time, this location was considered the western outskirts of the city. The station was demolished in the twentieth century.

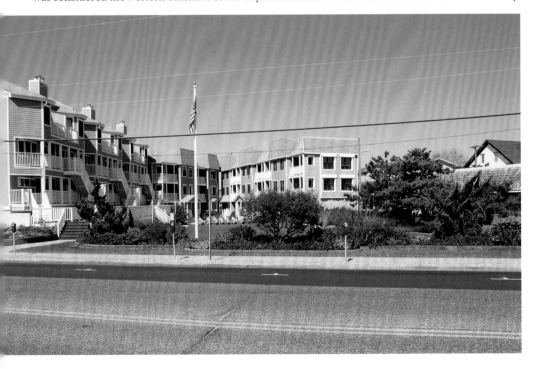

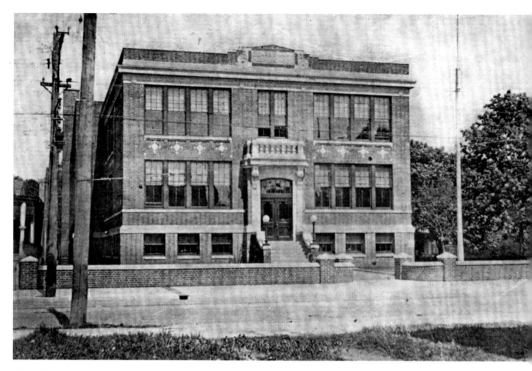

NEW HIGH SCHOOL: Atlantic City architect S. Harry Vaughn designed and oversaw construction of the new high school on Washington Street in 1917. It still stands next to the First Methodist Episcopal Church and was erected on the former site of the Colonial Cottage, a pre-Revolutionary War house which was moved to the rear of an adjoining lot. In 1961, the school became Cape May City Hall, a use that continues today.

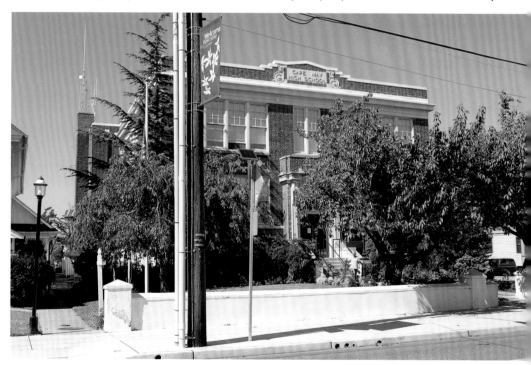

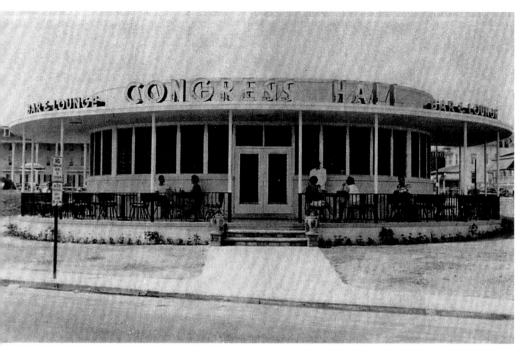

CONGRESS HALL BAR AND LOUNGE: In the 1950s, Congress Hall built a futuristic-looking bar and lounge on its front lawn overlooking the ocean at the corner of Perry Street and Beach Avenue. At the time, nearby Wildwood was erecting hotels with similar space-age details. The building's semi-circular south end capitalized on the waterfront views and the front porch offered sheltered outdoor dining. The porch has been enclosed and the building is now a popular pancake house.

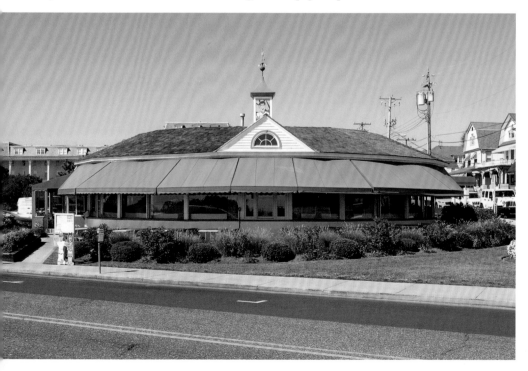

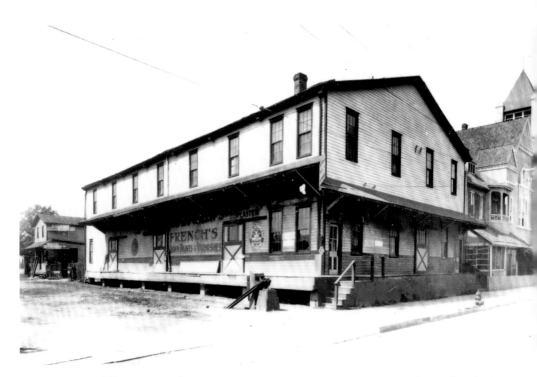

WAREHOUSE ON WASHINGTON STREET: Taking advantage of its location next to the Reading Station on the north side of Washington Street, this warehouse had its own railroad siding for loading and unloading goods. The 1909 Sanborn Insurance Company map identifies it as a furniture warehouse on the first story with storage on the second story. The structure was torn down in the mid-twentieth century, and its site is now occupied by a modern shopping center.

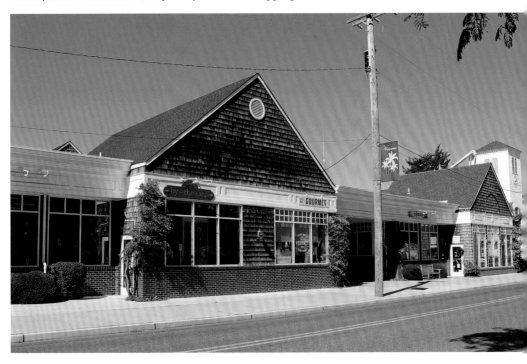

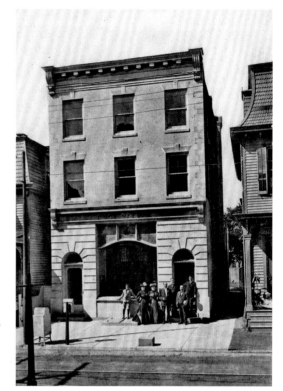

POST OFFICE ON OCEAN STREET:
Erected around 1900 and still easily
recognizable today, this three-story brick
building at #210 Ocean Street served as the
city's post office around the turn of the
last century. The structure also housed the
telephone company, U.S.O., and restaurants.
In 1923, the post office moved to the new
Focer-McCray building on Washington
Street and then to its current building, also
on Washington Street, about 1938.

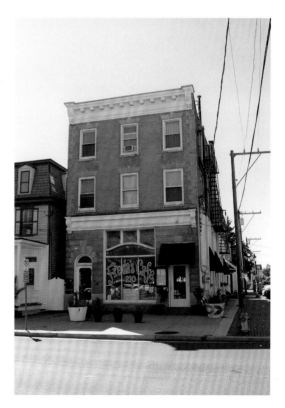

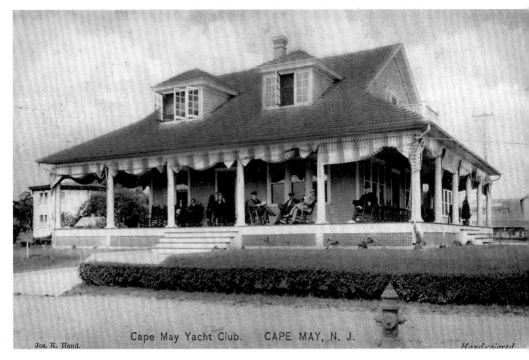

Cape May Yacht Club. CAPE MAY, N. J.

Jos. K. Hand. Hand-colored

CAPE MAY YACHT CLUB: Incorporated in 1904, the Yacht Club built this clubhouse that same year at the head of Washington Street near Schellenger's Landing, convenient to the docks and boat slips there. Surrounded by a broad porch on all four sides, the building contained a restaurant and sleeping quarters used by its members and their guests. Seen in the left background is the *ca.* 1875 Octagon House on Lafayette Street, which still stands. A modern gas station occupies the site today.

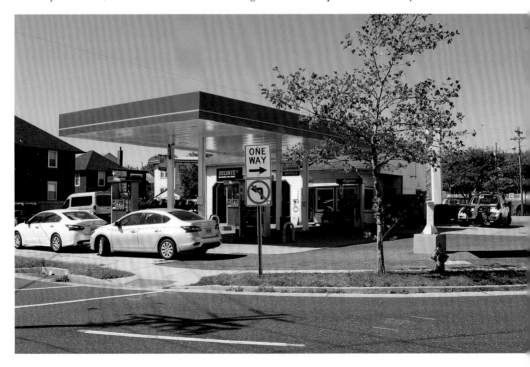

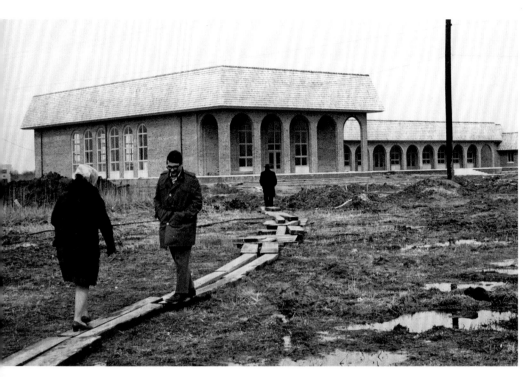

SHELTON COLLEGE: Reverend Carl McIntire, a fundamentalist minister and radio evangelist, moved Shelton College from northern New Jersey to this new building erected in 1964 at the corner of Baltimore and New York Avenues in East Cape May. A Christian liberal arts school, it flourished for several years, but after failing to maintain state accreditation was moved by McIntire to Florida. The building was demolished in 2014.

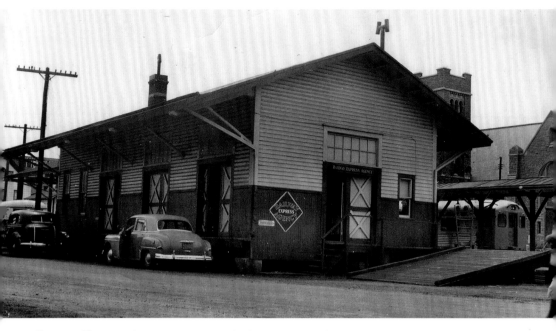

RAILWAY EXPRESS AGENCY: Located in the former Reading freight depot behind the passenger station on Washington Street, the Railway Express Agency provided small package and parcel transportation using extant railroad infrastructure throughout the country. It was established by the federal government in 1917 in response to World War I, but was disbanded in 1975 when the business model ceased to be viable and overall rail traffic had decreased substantially.

CAPE ISLAND PRESBYTERIAN CHURCH:
Local contractor Peter Hand erected this
church on Lafayette Street in 1853 for the
Presbyterians, crowning it with an unusual
onion-curved cupola unlike any other
in the city. After the Presbyterians built
a new church in 1898, the Episcopalians
worshipped here until 1953. The building
was then used as a community center until
a $1.4 million capital campaign allowed
restoration of the church and creation a
state-of-the-art theatre, known as Cape
May Stage, inside it.

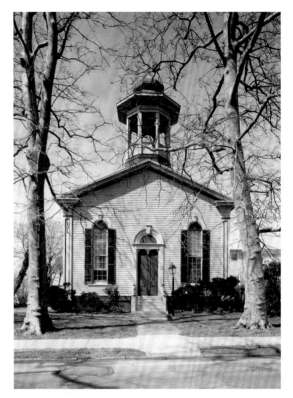

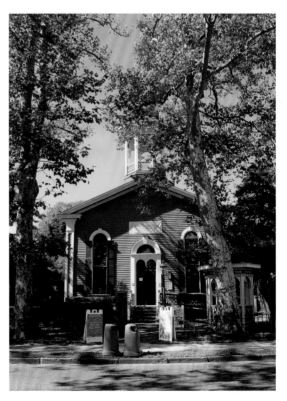

ACKNOWLEDGEMENTS

We want to thank the following individuals and organizations that provided the historic images used in this publication:

Naval Air Station Wildwood Aviation Museum
Cape May County Historical and Genealogical Society
Don Pocher
Greater Cape May Historical Society
Mid-Atlantic Center for the Arts and Humanities
Wildwood Historical Society
Library of Congress
New York Public Library
H. Gerald MacDonald